ORDINARY WOMEN, EXTRAORDINARY LIVES

*Further details of Poppyland Publishing titles can be found at*
**www.poppyland.co.uk**
*where clicking on the 'Support and Resources' button*
*will lead to pages specially compiled to support this book*

*Join us for more Norfolk and Suffolk stories and background at*
**www.facebook.com/poppylandpublishing**
*and follow* **@poppylandpub**

# Ordinary Women, Extraordinary Lives:

## Norfolk women in the first half of the twentieth century

by
Frank Meeres

POPPYLAND
PUBLISHING

First published 2017 by Poppyland Publishing, Cromer, NR27 9AN
www.poppyland.co.uk
ISBN 978 1 909796 31 7
Designed and typeset in 12 on 14.4 pt Gilgamesh
    Printed by Lightning Source

Picture credits:

Many of the illustrations are from the holdings of the Norfolk Record Office: I am grateful to
the County Archivist, Gary Tuson, for permission to use these images.

Author: 53, 54, 75, 113 (top), 113 (bottom), 114 (left) 114 (right).
Author's collection: 9, 18, 20, 25, 28, 37, 40, 50, 55, 59, 61, 76, 78, 102, 106.
Norfolk Record Office: 17, NRO, MC 2165/3/11;  36,  NRO, NNH 114/2;  43, NRO, MC 2194/3;
49, PD 523/5;  60, NRO, MC 2183/15; 63,64 NRO, MC 2333/1/1; 68, NRO, BOL 4/45; 70, NRO,
MC 2557/1 (top); MS 11322 (bottom right); MC 109/106 (bottom left); 71, BR 124/82; 72, NRO,
MC 2557/1; 86, NRO, MC 2532/2; 87, NRO, KHC 114; 94, NRO, KHC 114; 96, NRO, KHC 114;
97, NRO, FC 76/161; 99, NRO, FC 76/169/17.

Other titles by Frank Meeres from Poppyland Publishing:

   *Dorothy Jewson: Suffragette and Socialist*

Associated titles from Poppyland Publishing:

   *Lilias Rider Haggard: Countrywoman*                Victoria Manthorpe
   *A Forgotten Norwich Artist: Catherine Maude Nichols*   Pamela Inder & Marion Aldis
   *Nine Norfolk Women — Succeeding in a 19th Century Man's World*
                                                        Pamela Inder & Marion Aldis

# CONTENTS

# Introduction

This book tells true stories about Norfolk women in the first half of the twentieth century, at a time when women are just beginning to achieve equality in politics and in other spheres of life. The first chapter looks at the development of the suffrage movement in Norfolk, and tells the stories of Norfolk suffragettes who risked prison, and even their lives, for the cause. Following chapters look at a range of Norfolk women serving their country in the First World War but in very different ways — some as nurses, others a peace-makers, campaigning against the war itself. Chapters on the 1920s looks at the advances made by women in politics, and also at the flourishing literary and artistic scene in the county.

The book then looks at women in Norfolk involved in the Second World War, including several who found themselves involved in the Holocaust in a range of different ways. It concludes by telling for the first time ever the story of Eugenia Zagajewska, a Polish refugee who died in Norfolk in 1946: starting from the simple fact of her gravestone in Earlham Road cemetery, the author has been able to piece together the story of her short life, one involving many dramatic adventures.

# 1

# Norfolk suffragettes

The great issue for women a century ago was the campaign for the right to vote. The suffragette movement in the pre-war years was fought hard in Norfolk. Many women, including Norfolk women, were prepared to risk arrest and imprisonment for their beliefs. Others remained within the law, but were prepared to help financially and in other ways, such as **Dorothy Jewson**, whose life I have described in another Poppyland publication.

Although women could not vote in Parliamentary elections before the First World War, they could vote - and stand for election - in various forms of local government before this date. The first place where women obtained administrative power was the *School Boards*. School Boards were established under the *Education Act* of 1870, to provide elementary education for all children, The Boards raised a rate to fund building new schools and were elected by local ratepayers. The Norwich Board had thirteen members and the Boards had a unique voting system. Each ratepayer had thirteen votes and could cast them in any way they wanted: if they chose they could put all their thirteen votes on a single candidate! This was as a protection for minority interests: for example, Roman Catholics might put all their votes on a single candidate and thus get one person on the Board representing their interests. People who thought it important to have a woman on the Board could do exactly the same thing.

Education was generally accepted as being an issue of especial concern to women, so there was no controversy as to their role on these Boards, but they were always very much in a minority. The first women on the Norwich School Board were **Charlotte Lucy Bignold** and

**Mary Anne Birkbeck** elected in 1881. Perhaps their full potential was not yet appreciated — they did not serve on the two major committees of the Board, the Finance Committee and the Buildings Committee, but found roles on the Examinations Committee and the School Attendance Committee.

Charlotte, always known as Lucy Bignold, was the daughter, said to be the favourite daughter, of Sir Samuel Bignold of the Norwich Union. Born in 1835, she never married and lived for fifty years at Stanley House in Surrey St (from 1875 until her death in 1924). Mary Ann Birkbeck was a younger woman, thirty years old when first elected for the Board. She was a member of a well-known landowning Norfolk family, and lived at Stoke Holy Cross, south of Norwich.

Both women were re-elected in 1884. Mary Ann Birkbeck married Samuel Gurney Buxton of Catton Hall in 1886, and thus, as Mrs Buxton, became the first married woman on Norwich School Board. Both women stood in 1887, along with a third, **Annie Burgess**, wife of a well-known Norwich radical Edward Burgess. Lucy Bignold and Annie Burgess topped the poll, but Mary Ann Buxton was defeated, so as before there were two women out of thirteen Board members.

These women were followed by **Emma Green** and **Margaret Pillow**, both elected in 1893. Margaret Eleanor Pillow, born Margaret Scott, was an important educationalist, writing books on domestic economy and acting as a national inspector of school cookery classes. She was the first female to take the examinations of the Royal Sanitary Institute, an illustration of how women were breaking through so many barriers in the last decades of the century. However, she was only on the Norwich School Board for three years.

It was very rare for there to be more than two women on the Board at any one time, and sometimes there were none at all, as on the Board elected in 1896 for example. Most women stood in political alliance with male colleagues, such as Lucy Bignold, a Conservative, and Emma Green, a Liberal. Others were independent of political parties, like Margaret Pillow.

Other Norfolk School Boards saw the same pattern of a small number of women members. **Ethel Leach** was elected for the Yarmouth School Board in 1881. She had been born Mary Ethel Johnson in 1851. She married John Leach, of the Yarmouth hardware firm, in

1869, and they had one son, Bruce. She was a committed advocate of votes for women, and had held a suffrage meeting in her house in Yarmouth Market Place in March 1880, attended by almost fifty people — mostly men. In 1885, she acted as election agent for Helen Taylor in Camberwell: Helen was probably the first woman ever to attempt to run as a parliamentary candidate, but her campaign came to an abrupt halt as officials refused to accept her nomination. Ethel led the way in introducing kindergarten methods into Yarmouth junior schools. She was re-elected every three years, and even became vice-chairman of the Board in 1895. School Boards were abolished in 1902 and schools run by local authorities: women could not be councillors so their elected role in education affairs came to an end. Their worth is shown by the fact that women were commonly co-opted onto education committees after 1902, as Ethel Leach was: her husband died in the same year, so her later career was as a widow.

The next field for women to conquer was that of *Guardians of the Poor*. These were elected every three years from 1834 onwards, and were responsible for caring for those in need: they raised a rate for this purpose. Poor Law Guardians had to be people of substance, rated at over £15 a year. Whether women could stand as guardians was unclear for the first 40 years of operation of the *New Poor Law Act* of 1834, and none did in fact try to do so. The first woman ever to be elected was in 1875 in Kensington. Emmeline Pankhurst herself cut her political teeth in this field: she was elected to a Board of Guardians in 1893. The property qualification was abolished in 1894 and this led to the election of many more women Guardians. The first female Poor Law Guardians in Norwich were **Emma Rump**, **Kate Mitchell** and **Alice Searle**, all elected in December 1894. **Annie Reeves** became the first Labour woman to obtain political office when she was elected to the Norwich Board of Guardians after the 1894 rule change. Annie was a well-known local character: she was a former Salvationist and lived in a house off St Stephen's, later to be turned into a flea-pit cinema.

Other Boards also began to have women members. By 1894, there were about forty women on the various Boards in Norfolk, Erpingham leading the way with six women members — however, seven Norfolk Boards still had no women at all. Ethel Leach became a Guardian of the Poor in Yarmouth in 1895, one of three women on the Board:

they were known as 'the Trinity'. Ethel led the way in bringing trained nurses into the workhouse, and also in helping children moved out of the general workhouse wards into cottage homes. Many of the women were 'upper class', often the wives or daughters of the local squire or local rector, but there were a few from the working class: in Erpingham, George Edwards, the farm workers union leader, and his wife **Charlotte Edwards** worked together on a Board whose other female members included **Lady Durrant** of Scottow Hall, and **Mrs Hoare**, the wife of the vicar of Aylsham.

*Parish and district councils* were established under an Act of 1894: women could both vote in these elections and stand as candidates. Some twenty women were elected to the first parish councils in 1894, usually just one woman on each council but three villages could boast two (Reedham, Topcroft and Stibbard). The same women often served on Rural District Councils as well — Erpingham Rural District Council, for example, had three women which included **Blanche Pigot** who was also on Sheringham parish council. No women were elected on Urban District Councils, but a few women represented an urban council on the Rural District Councils for poor law purposes, as did **Kate Fitch**, the daughter of the vicar of Cromer. Blanche and Kate were both Poor Law Guardians as well: it was common for the same few women in each area to serve in all possible capacities, Poor Law Board, Parish Council and District Council.

The Act did not affect a city like Norwich, which of course already had its own city council, or boroughs like Great Yarmouth. Women could not stand as candidates to these councils. However, they could vote in council elections, provided they were occupiers or householders of a property other than that for which their husband claimed his vote. A major advance came in 1907: from this date women could sit on *City, Borough and County Councils*. Annie Reeves was the first woman to try for election to Norwich City Council, standing for Labour in Wensum ward in 1908 and 1909. She was unsuccessful on both occasions, but the 275 people who voted for her in Wensum ward in 1908 were the first Norwich citizens to vote to put a woman on to the city council. Ethel Leach stood for Great Yarmouth Borough council in the same year, but she was also unsuccessful.

There had been some activity in the direction of women's suffrage in

the nineteenth century with the formation of several groups promoting the cause. A decisive step forward came when the *National Union of Women's Suffrage Societies* was founded in 1897 by Millicent Fawcett: its members were known as *suffragists*. A rival group, the *Women's Social and Political Union* was founded in 1903 by Emmeline Pankhurst and her daughters Christabel and Sylvia: they thought the already-existing group was too feeble, and also too middle class. They were a militant group, but this word needs to be placed in the context of its time. The militant acts of the IRA and of some fundemental Islamic groups in

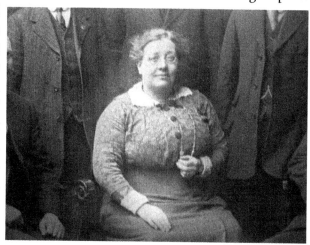

the later 20th and early 21st centuries are a world apart from the militancy of the suffragettes. Their 'militancy' consisted at first of shouting down politicians, and of marches which often involved c o n f r o n t a t i o n with the police. In 1905 Christabel Pankhurst and Annie

*Annie Reeves, the first woman to stand for Norwich City Council in 1908 and 1909.*

Kenney attacked a policeman who tried to remove them after they interrupted a meeting held by Sir Edward Grey. They were fined and, on refusing to pay, were sent to prison. From this time the members of the WSPU became known as *suffragettes*.

The WSPU became more and more active. In February 1907, a convention calling itself a 'Women's Parliament' met at Caxton Hall in London. About 800 women marched to the Houses of Parliament, where they were involved in violent confrontations with the police. In the Commons the next day, a Mr Hay protested at the police violence: 'Women had rights as well as men'. Keir Hardie said that an eyewitness had told him that excessive violence had been used. Herbert Gladstone said that he had no reason to suppose that this was the case. Around seventy women (and two men) were charged after the events: none was from Norfolk.

In September 1907, the WSPU itself split. Emmeline Pankhurst, like several other WSPU leaders, had been a member of the ILP. Now she formed what she called the national WSPU whose members had to sign a pledge not to support *any* party at parliamentary elections until women had obtained the vote. Those members who wanted to work with the Labour Party had to leave: they formed a new group called the Women's Freedom League. This, naturally, tended to take in the working class women, so that, in practice, the national WSPU became increasingly a middle class organisation.

In fact many of the WSPU members were distinctly aristocratic. They included **Princess Sophia Duleep Singh**. Sophia was the daughter of the Maharajah Duleep Singh, the last emperor of the Sikhs, who had been deposed by the British and had made his home at Elveden in Suffolk. Sophia had been brought up at Elveden, but after her father's death lived in 'grace and favour' apartments at Hampton Court Palace. She was also one of the 'distinguished women' who marched with other suffragettes to Westminster on 18 November 1910: the arrest of 176 of them and the violence used led to the day becoming known among suffragettes as 'Black Friday'. *The Suffragette* carried a photograph of Sophia selling the newspaper outside Hampton Court.

In January 1908, Herbert Asquith paid a visit to Norwich: he was Home Secretary at the time and soon to become Prime Minister. He spoke to a crowded St Andrew's Hall. Special arrangements were made to keep out the suffragettes, but the women were too clever. His speech was interrupted every few minutes by women jumping to their feet and calling out 'Why don't you give us the vote?' Each one had to be hustled out, accompanied by male cries of 'Hoist her upside down!' Asquith, of course had seen it all before, and was in any case a consummate politician. As the writer Ralph Mottram recalled: 'He went on with the next word, as the clamour subsided, imperturbable and lucid'.

Sixteen of the evicted suffragettes then tried to hold a meeting in front of the Sir Thomas Browne statue in the Haymarket, but, according to the press, 'the large crowd which gathered was decidedly hostile. Fish offal and mud were thrown and choruses sung, and finally the attempt at speech making was abandoned, and the ladies left the scene'. Some stayed overnight and distributed leaflets in the Market Place on the Sunday, before taking part in services in the 'Labour Church', a nearby Christian Socialist meeting place.

One of the greatest of the many peaceful demonstrations and marches by the suffragettes was the gathering at Hyde Park on 21 June 1908. Norwich WSPU women were there. There was a special train from Norwich to Liverpool Street. The women were to be at Norwich station by 9.30 am, and to bring their own lunch 'as none can be obtained in London'. They were to march from Liverpool Street to a pre-determined point in Hyde Park. After the march they were to meet the organiser at Marble Arch 'where I shall be pleased to give any information, and friends who may have been separated in the crush can find each other'. Then they were to come back on a special bus or by tube and meet under the big clock inside Liverpool Street station. Tea (at nine pence a head) would be made available at the station for any woman who had let the organisers know in advance.

The event as a whole was an enormous success. The *Eastern Daily Press* estimated that a quarter of a million were present in Hyde Park: some other estimates put it as high as half a million. The Norwich contribution was rather less impressive. There were 250 women from Norwich on the train (a further 150 applied for tickets too late and had to be turned away). Other women joined the train at Ipswich, Colchester and Chelmsford to make a total of 400 women from East Anglia. The national organisers were not impressed - one remarked 'I consider that Norwich has done rather badly'. The women were supposed to stick together as a group in Hyde Park. Instead they wandered about in small parties trying to find the most famous WSPU speakers like Mrs Pankhurst or Annie Kenney. Rather than returning to Liverpool Street in a disciplined body, 'they arrived in twos and threes'.

The EDP reporter noted that, when the Norwich banners passed by on the way to Hyde Park, the London crowd called out 'Canaries'. He was not sure if this referred to the local football team or whether it was 'a playful way of expressing the truly Cockney idea that Norwich people all live by breeding little birds'.

On the same weekend as the great march, there was a Labour Party fête in Norwich. It was held at Fern Hill in Thorpe Hamlet, the home of Isaac Coaks, a wealthy Norwich solicitor. George Roberts, Norwich's pro-suffrage Member of Parliament, was there together with Dorothy Halling, an actress 'who has recently left the stage to devote herself to Socialist propaganda'. Roberts congratulated the women of

Norwich on the zeal and activity they were throwing into the Socialist and Labour movement, which, he said, was steadily attracting some of the brightest and best women in the community. He heartily welcomed their aid:

> We of the Labour Party believe that if women are good enough
> to get votes for us, they are good enough to vote on their behalf,
> and we believe the time is fast approaching when women will
> have the same rights as men in that matter.

He added that some people were querying the methods of the suffragettes but it could not be denied that their methods had been eminently successful so far. Miss Halling said that women were not coming into the Socialist movement as fast as she hoped: however Norwich was a 'brilliant exception'.

It was the charisma of the Pankhursts that attracted younger women into the WSPU rather than the NUWSS. In 1910 Christabel Pankhurst spoke at Great Yarmouth, creating an impression that 21-year old **Henrietta Grenville** was to remember over 60 years later: 'I was so impressed by her elegance, the way she put things. I was convinced by what she had to say and after hearing her, wrote to headquarters to ask what I could do'. In the event, Henrietta's contribution was confined to the handing out of leaflets but some local women were prepared to follow the Pankhursts further.

One tactic adopted by the WSPU was to campaign at by-elections in support of the candidate most likely to defeat the Liberal candidate: this was to be the women's revenge for the refusal of the Liberal leader, Asquith, to support the fight for the vote for women. The tactic also gave them publicity as the newspapers reported the progress of the by-election campaign. Besides, there was always the chance that the Liberal might actually be defeated. This became much more important after the two general elections of 1910, when the Liberal government had only a tiny majority over the Conservatives.

There was only one by-election in Norfolk in this period, in the rural seat of North West Norfolk: this was held on 31 May 1912. Added importance was given to it by the suffragettes because Emmeline Pankhurst and two of her supporters, the Pethick Lawrences, were

actually on trial at the Old Bailey while the fight was on: on 22 May they were each sentenced to nine months in prison.

The campaign in the constituency appears to have got off to a slow start, many of the women preferring 'sunbathing and gossiping' to the rigours of electioneering. There was a dispute as to who should lead their battle, **Margaret West**, the Norfolk WSPU organiser and an impressive speaker, or the Eastern Counties organiser **Grace Roe**. Just a week before the by-election the pace quickened after Roe was placed in sole control.

However there was an obvious problem with the WSPU idea, which was exposed in this by-election. They were committed to trying to defeat the Liberal candidate – but the Liberal could well be the only candidate who was in favour of giving the vote to women! Their candidate in North West Norfolk was a lawyer named Edward Hemmerde and he said in his election speech, as quoted in the *Eastern Daily Press*:

> Personally he thought every man should have a vote. He had always thought so. And personally he thought that every woman should have one too (Laughter). He had come round to that conviction in spite of many prejudices which he still felt, and no amount of breaking of windows by some fanatical members of the crusade would alter his opinion. He had never been able to understand how the vote could be refused to any intelligent human being of age.

His only opponent was the Conservative – and conservative – Norfolk squire, Neville Jodrell, of Stanhoe Hall. He had no interest in women's suffrage, but it was he whom the WSPU campaigners had to try and get elected. As the *EDP* commented: 'the young ladies of the WSPU is 'agin the Government' and is therefore opposing the only candidate at the election who has the least sympathy for the suffragette ideal'. Mrs Hemmerde, the candidate's wife, made the same point when she came face to face with a WSPU suffragette, a Miss T Jones. She added, however, that she had not a scrap of sympathy for people who broke windows. The NUWSS were more logical in their approach, giving Hemmerde their 'qualified' support.

The WSPU campaign came to a climax with a huge meeting at King's Lynn on the day before polling day. It was held at St James' Hall which had 1,100 people inside: a further 600 or 700 people formed an overspill meeting outside. It was estimated that about half the crowd were male.

In the event, Hemmerde won the seat by 548 votes. The suffragettes could claim a victory of sorts as the Liberal majority was reduced by half, but of course there were many other factors involved in the campaign besides women's rights. Norfolk farm labourers were highly unionised. A letter of support from the ailing farm workers' union leader and former MP for the area, Joseph Arch, was probably worth at least as many votes to Hemmerde as the disapproval of the WSPU cost him.

The WSPU in Norwich invited Emmeline Pankhurst herself to speak at a meeting at St Andrew's Hall, Norwich, on 11 December 1912. The Hall was packed, but the audience included a large number of male youths whose sole purpose was to shout down the speakers: they chanted and sang throughout Emmeline's speech, including many renditions of a local football favourite, 'On the Ball, City'. Their brutishness provoked a contrary reaction, with many Norwich people – both men and women – expressing their outrage that Emmeline had not been given a hearing in the city.

More aggressive action was starting to be taken in Norfolk. In February 1913, a nation-wide campaign to damage golf courses was organised. Cromer was one of those selected: according to the local press, 'flags were stuck in the hacked turf, bearing such inscriptions as **War or Government Measure** and **Better be Hostile than Indifferent**. A man and three women were seen running away from the links'.

The campaign against property was also to be fought hard in Norfolk. On the morning of Sunday 6 April 1913 a mansion at Eaton Chase, off Newmarket Road in Norwich, was found to be ablaze. The house had been built for W H Webster, but he had died suddenly and the interior of the house was unfinished. Suffragettes were suspected. Margaret West was non-committal. She said that she neither claimed nor disclaimed responsibility - 'in view of what was happening in other parts of the country it might well be the work of suffragettes'. *The*

*Suffragette* reported the Eaton Chase fire in the same way as it did other arson attacks, with relish but without actually stating that it was started by suffragettes.

Window smashing came to Norwich as well. In May the brand new plate glass frontage of Bunting's drapery stores (now Marks and Spencer) in Norwich was defaced with seven-inch high letters reading VOTES FOR WOMEN. The damage was estimated at £1,200. The store re-opened with new glass on 4 June.

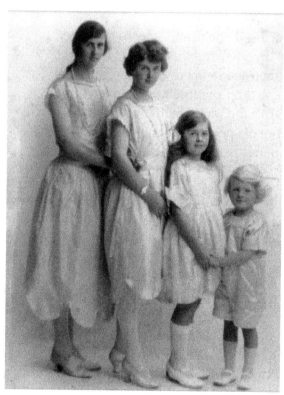

*The Aitken children: Violet is second from the left.*

Several Norfolk suffragettes are known for activities outside their native county. One suffragette with Norfolk connections was **Violet Aitken**, the daughter of William Hay Aitken, a canon of Norwich Cathedral. Violet was born Marian Violet Aitken in Bedford on 21 January 1886: she was one of twin girls, her sister being christened Wilhelmina. The couple had an older son and daughter, and another daughter and son were to follow. Violet was another suffragette campaigner from a privileged background, brought up in a house with several live-in servants. Aitken became a canon in 1900 and took up residence in the Close in Norwich. His family, including Violet, then aged fifteen, were still in Bedford at the time of the 1901 census, but soon moved into the Close. Over the next few years, all the daughters spread their wings. In January 1910, Aitken recorded in his diary that it was difficult to believe the twins were 24:

they were clearly living away from home by this time as he sent each of them a wire. By the time of the 1911 census, only the youngest son, Wilfred, then aged nineteen, was still living with their parents. Violet, who would then have been 25, does not appear on the 1911 census at all — probably she was one of those women who deliberately avoided being recorded as part of their protest.

Then, from the canon's point of view, it all went horribly wrong. His diary entry in March 1912 captures the horror he felt at Violet's activities:

> A letter from Miriam enclosed one from Violet to the effect that she had been again arrested and this time for breaking plate glass windows. I am overwhelmed with shame and distress to think that a daughter of mine would do anything so wicked. I can only throw the whole matter on Him who is the great burden bearer of his people. But my poor wife! It is heartbreaking to think of her being exposed in her old age to this horror.

Violet had joined together with another suffragette, **Clara Giveen.**

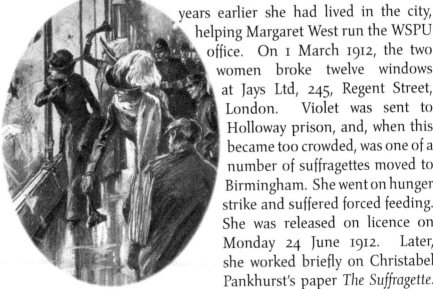

Clara had Norwich connections too: some years earlier she had lived in the city, helping Margaret West run the WSPU office. On 1 March 1912, the two women broke twelve windows at Jays Ltd, 245, Regent Street, London. Violet was sent to Holloway prison, and, when this became too crowded, was one of a number of suffragettes moved to Birmingham. She went on hunger strike and suffered forced feeding. She was released on licence on Monday 24 June 1912. Later, she worked briefly on Christabel Pankhurst's paper *The Suffragette*. Never marrying, she lived to be

*Suffragettes smashing windows in London.*

over a hundred, dying in Barnet in November 1987 at the age of 101.

The local campaign continued through the summer of 1913. In June the Norwich group announced that they would hold countryside meetings: 'will those who can cycle and are willing to help work up the Meetings send in their names' to organiser Margaret West. The branch also went to the coast to try and win over holidaymakers to the cause. However, these local happenings were soon overshadowed by a national tragedy.

Perhaps the most sensational single event in the suffragette campaign occurred on 4 June 1913. **Emily Davison**, a member of the WSPU, bought a third class ticket to Epsom. She stood at Tattenham Corner to watch the Derby. As the king's horse approached, she ran onto the course and grabbed its bridle. The horse rolled over her injuring her severely. She lingered for several days, dying at 4.30 pm on 8 June.

Her death naturally filled the newspapers for days, giving enormous publicity for the cause. It caused ripples locally too. On 13 June there was a meeting of the Norwich WSPU at the Thatched Assembly Rooms, chaired by Margaret West. The main speaker was a Miss Naylor. She said that critics of the movement described it as being made up of silly hysterical girls, led by a few clever women: they were entirely ignorant of the type of women who belonged to it.

Emily's funeral took place on the following day. Her coffin was carried across London at the head of an enormous procession of women. They processed to King's Cross Station, where the coffin was put onto a train to Morpeth, Emily's home town, for burial. The Norwich WSPU sent a wreath to Davison's funeral with a text that read:

THE LOVE OF LIBERTY WITH LIFE IS GIVEN; AND LIFE
THE INFERIOR GIFT OF HEAVEN.

Emily Davison can be added to the list of suffragettes with Norfolk connections, as she was a resident of Cromer, at least for a short while — and may owe the toughness of her character to her time there! This suggestion comes from a biography of Emily written by Gertrude Colmore in the wake of Emily's death. Ms. Colmore says that Emily stayed in the town, and in one year was 'the last of the bathers', continuing

to swim in the sea even in November. The writer comments: 'it was an early indication of the kind of physical hardiness she was to have need of later in life when suffering the rigours of prison.' The background to this is that Emily Davison was private governess to the family of Francis Layland-Barratt in the early years of the twentieth century. He was Member of Parliament for Torquay, and had residences in Chelsea, and also in Torquay (The Manor House) and at the Red House in Cromer. Emily moved between these residences with the children, daughters Dorothea (17), Petronel (14), Frances (8) and son Francis (6) — these are their ages in 1903.

Archival evidence survives in the form of postcards sent by Emily Davison to a relation, Jessie Bilton at Whitley Bay. Postcards from Cromer include two that are dated 16 September 1903 and (day illegible) March 1904 so she was certainly in the town on those dates. These cards confirm her obsession with sea bathing. That of September asks Jessie 'Have you bathed any more?' while another card reports: 'I had my last Bathe on Friday October 7th. Bathers are up now', meaning that the bathing machines have been pulled off the beach as the season has ended. She clearly liked Cromer, writing on the back of a view of High Street 'here is a favourite view'. One postcard is of Red House itself, a cross marking the window of her bedroom (looking at the house, it is the right hand of the two dormers between the brick gables). This was some years before Emily Davison became a full-time worker for the suffragette cause, and it is not known if she attended local meetings while in Norfolk, but it is interesting to think of her as a resident of this Norfolk seaside town.

Dorothy Jewson was one of about twenty women thanked in *The Suffragette* in February 1913 for her help in organising jumble sales and a stall in Norwich Market Place: other names included that of 'Miss Pratt'. **Miriam Pratt** was a close friend of Dorothy and her brother. She had been born in Surrey in 1890, but was brought up in Norwich by her uncle, George Ward, a local policeman. She had begun her career as a pupil teacher at Nelson Street school. She moved to Sir George White School for Girls in September 1907: her address at this date was 1, Mill Hill Road. On 15 May 1908 she was given a day's leave by the school to go to an interview at Homerton College in Cambridge. She was successful and left the school at the end of August 1908 to attend the

college. She returned in 1911 to become a teacher at St Paul's school in Norwich — and an active and militant suffragette.

*Miriam Pratt (in white hat) demonstrates in Norwich Market Place.*

In May 1913 the attention of the Norwich branch of the WSPU switched to Cambridgeshire, where a by-election was being held: they went down to campaign in support of the Conservative candidate, John Denison-Pender. When he defeated the Liberal candidate on 16 May, the WSPU naturally claimed it was as a result of their campaigning! On 18 May, two buildings were burned down in Cambridge, first a new house being built for a Mrs Spencer of Castle Street, then a new genetics laboratory. Suffragette leaflets were found in both. A lady's gold watch was discovered outside the window used to get in to the laboratory. Ward recognised the watch as the property of his niece Miriam and informed the authorities. On 22 May, Miriam was remanded for a week, bail being refused. Ward said that he had given his niece a watch about five years earlier. He had read about the Cambridge incident, and remembering that Miriam had recently lost his watch, asked if it was hers. She denied it at first, but eventually admitted to him that she had been at Cambridge with two other people. She had a wound on her hand: she had cut it while trying to scrape out the putty round the window with her scissors. She begged him not to tell anyone but he 'shopped' her anyway. Ward said that Miriam paid him ten shillings a week in rent. She sold suffragette papers in the street and had keys to the suffragette offices in London Street.

Miriam was remanded in prison for eight days. She appeared at the court on 30 May 'with a smile of greeting for some of the ladies in court. She was wearing a blue dress and white gloves, and had a posy of sweet peas at her breast'. Bail was agreed with two sureties of £200 each: Harry Jewson, Dorothy's brother, put up one and an unidentified Cambridge lady the other.

The case swept up the other Norwich suffragettes. Margaret West had been in Cambridge with Miriam, helping run the WSPU campaign in the East Cambridgeshire by-election. She was present in court. Dorothy was closely involved too: she organised Miriam's defence fund. The trial was not to be held for a further four months: in the meantime Miriam was suspended from her teaching work at St Paul's school: the Education Committee in Norwich instead employed her in their central office, pending her trial.

When suffragettes were sent to prison, it was a common practice by them to go on hunger strike in protest. This led to the horrors of forcible feeding, an unbelievably painful and humiliating process which outraged many people who were otherwise indifferent to the cause. However, the alternative was to let the women die, which would have created martyrs. The Home Secretary, Reginald McKenna, came up with an idea to get around the problem. He rushed through an Act in March 1913 which provided that a hunger striker would be released if her life was in danger but would have to go back to prison as soon as she was well enough to do so. This became known as the *Cat and Mouse Act*.

On 3 July, Clara Giveen and another suffragette, Kitty Marion, were convicted of setting fire to the grandstand at Hurst Park racecourse on the night of 8 June, the day of Emily Davison's death. Clara said that no sentence could be passed as they had not been convicted by a jury of their peers: 'until women were on the jury as well as men no sentences should be passed upon women'. The women were both sentenced to three years imprisonment. Both went on hunger strike and were released within a week under the new Act.

Margaret West wrote to the EDP on Friday 18 July, announcing a protest meeting on Norwich Market Place on the following Sunday. On Saturday a letter appeared over the names of Dorothea Jewson (her proper name, although always known as Dorothy), Fred Henderson, Herbert Witard, Rev W H Marcon and Rev Anthony Fenn. It urged

people to attend the meeting to protest against the Cat and Mouse Act:

> Under it women are just as assuredly — if more slowly and less dramatically - being killed, as they were under the old barbarous system of forcible feeding.

The letter concluded 'We wish it to be understood that support of the meeting does not in any way involve support of militant methods'. The protest meeting was held in Norwich Market Place on 20 July. The speakers included Fred Henderson and local leaders of the WSPU, Margaret West and Kathleen Jarvis: some 2,000 people attended. Miriam Pratt was also there: a photograph of her at the meeting was published in the EDP for 15 October 1913. No doubt she was thinking ahead to her own likely imprisonment. Her continued suffragette activities were noticed by her employers. A meeting of the Norwich School Staff Committee on 15 September voted (by five votes to one) that her salary would only be paid if 'she absolutely refrained from taking part in any public demonstration with that Movement'.

On 14 October Miriam's trial was held at last. She conducted her own defence and skilfully cast doubt on the evidence of the watch. She said that it was a very plain one, implying that it might have belonged to anyone. Her final statement, however, was not a summing up of her case but a plea for a redress of the wrongs of women:

> I, as a teacher, am in a position to appreciate to the full the unfair distinction made between men and women teachers. In every one of our great cities and in most of our towns there are thousands of wretched women living in conditions of unspeakable filth and horror, who, by working day and night, and with the assistance of their children, even the babies, cannot earn six shillings, five shillings, even three shillings or two shillings a week.

At one point the judge interrupted her long speech to ask what it had to do with the case. When she replied that she was making her defence he retorted 'I thought your defence was that you did not do it (Laughter)'. The all-male jury seem to have been in sympathy with

the judge rather than the accused: they were only out for five minutes before returning with a verdict of guilty.

Miriam was sentenced to eighteen months in prison: naturally, she was also dismissed from her teaching post. She immediately went on hunger strike and was transferred to Holloway. She was very soon released for seven days under the *Cat and Mouse Act*, and went to recover with friends in Kensington.

On the Sunday after her conviction there were scenes at Norwich Cathedral, where the judge who had sentenced her was present for the morning service. During the prayers, several people - both men and women - stood up and offered the prayer 'Lord, help and save Miriam Pratt and all those who are being tortured in prison for conscience sake'. Printed copies of her defence address were distributed outside the building.

The demonstration in the Cathedral, together with Miriam's release, provoked a great deal of correspondence in the *Eastern Daily Press* in October and November 1913. An opponent wrote under the name 'Anti Humbug':

Dear me, are we to submit to our property being destroyed, our lives put in danger, our laws which are made for mutual protection set aside as of no moment, and then, when society insists on punishment for evil-doers, they whine and exclaim, you must not punish us because our consciences compelled us to do it.

'WHJ' - undoubtedly Harry Jewson - replied by drawing wider social issues into the suffrage question:

The women's revolt is part of a widespread refusal to accept the conditions of modern life, a protest against unfair laws, against sweated work for men and women, against the mean and poor life which so many live, when a fuller and more human life is more possible for all.

A writer calling himself Militant agreed:

The man who cannot see anything to admire in a young woman deliberately sacrificing her career and her liberty, and

afterwards by the hunger strike risking her life, even though he could not approve of her act, that man in my opinion is much to be pitied.

Autumn saw further outbreaks of the arson campaign. On 27 September 1913, one of the largest fires ever seen in Great Yarmouth broke out. At 2 o'clock in the morning the Southtown timber yard of W Palgrave Brown was found to be ablaze. The firemen took 24 hours to control the blaze. In October, the suffragettes' own newspaper announced: 'GIGANTIC FIRE AT YARMOUTH - Timber Yards a Sea of Flames. Damage estimated at over £40,000'. On the following day, three greens on Yarmouth golf links were damaged: cards in favour of the suffragettes were left on the course. A postcard was received by the local newspaper office which read: 'The Timber Yard was fired by Suffragettes. There is no mystery. Votes for Women.'

Yarmouth was a popular place for attempts at arson. A week after the timber yard blaze an attempt was made to burn down the Scenic Railway on the beach. As it was made entirely of wood the fire would have been a spectacular one, but the arsonists were out of luck. Fire-lighters and partly-burned cotton wool were found under a rail: high winds had probably put out the fire. The railway was valued at £20,000. On the morning of 10 October the pavilion of Wellington Pier was found to be on fire. It was soon brought under control. 'It was afterwards discovered that on the pier deck near the south entrance of the building were written in chalk in large letters the words:

<div align="center">VOTES FOR WOMEN</div>

More WSPU meetings were held in Norwich in February 1914. Nancy Lightman, one of their leading speakers, gave speeches at the Thatched Rooms and at the Bull Close Memorial Hall. On both occasions she had the support of an entertainment, a duologue called 'No 10 Clowning Street': no doubt this was Dorothy Jewson's contribution. Her brother Harry contributed yet again: he lent the Memorial Hall for the occasion, and also acted as chairman.

On 17 April 1914, the pavilion on the Britannia Pier in Yarmouth was destroyed by fire. According to The Suffragette, which carried a

photograph of the blazing building, suffragette messages were found on the beach nearby:

VOTES FOR WOMEN

MR McKENNA HAS NEARLY KILLED MRS PANKHURST

WE CAN SHOW NO MERCY UNTIL WOMEN ARE ENFRANCHISED.

Another suffragette from Norfolk was **Freda Graham**. She was born **Grace Marcon** in 1889 in the village of Edgefield near Holt. Her father was rector there for over fifty years, and was one of the signatories to Dorothy's letter about the *Cat and Mouse Act* already mentioned. In 1901, Grace and two elder sisters (Dorothea and Muriel) were boarders at a small school in Suffield Park, Cromer. She was with her parents at Edgefield at the time of 1911 census, where her occupation is given as 'gymnastic teacher'. Then her life took a dramatic new turn. Under her adopted name, she took part in suffragette activities in London in 1913 and 1914, which resulted in prison sentences and in hunger strikes. She is best-known for going into the National Gallery in May 1914 and slashing five paintings on display there with her cane. She was sentenced to six months in prison. Many such prisoners, as we have seen, went on hunger strike in protest at their treatment. Freda went further: inspired by her 'leader' Emmeline Pankhurst she refused not only food but also water, an intolerably painful form of self-sacrifice. She underwent this for two weeks — noted by Sylvia Pankhurst as the record for a suffragette on thirst strike — before being released. By the end she was in delirium: cutting off all her hair while alone in her cell. She was released on 8 June because of the injury to her health from her strike. She was then cared for in a 'safe' house in London. The police visited her on 12 June: she was being cared for by two nurses and was still too ill to be examined.

Miriam, Violet and Freda are all on the suffragette 'roll of honour', of women sent to prison and going on hunger strike for the cause of obtaining the vote for women.

Other women who believed in their rights made their mark by

serving on local authorities, and proving that their abilities were at least equal to those of men. In 1913, **Mabel Clarkson** became the first woman on Norwich City Council: she stood as a Liberal. Born in 1875, Mabel was the daughter of a solicitor. Her whole life was devoted to improving the conditions of the poor within the City. She was a member of the Board of Guardians from 1904, nine years later achieving her success: as no elections were held in wartime, she was the sole woman on the City Council for six years. There were no women at all on Norfolk County Council until after the First World War.

*'Freda Graham', real name Grace Marcon.*

The war changed everything. When it broke out on 4 August 1914, the WSPU suspended all political activity. A truce was declared: the prison sentences on women like Miriam Pratt were cancelled. Emmeline and Charlotte Pankhurst were strong supporters of the war and of the duty — and right — of women to fully participate in it. However, many of the suffragettes could not follow the Pankhurst's lead and led the way in anti-war activities. In contrast, other women thought it was their duty to play a full part in the war, many in the 'traditional' women's role of nursing, work which demanded courage as well as compassion.

# 2

# Edith Cavell, Jessie Hayward & Norfolk nurses serving abroad

Most people know the story of **Edith Cavell**, the subject of many books and several films. Born in Swardeston, Norfolk, she was a nurse who was working in Brussels when the First World War broke out. After Brussels had fallen to the Germans, she remained at her post continuing her nursing work - but she was also part of a group that helped smuggle Allied soldiers through enemy lines to safety. For this, she was shot by firing squad on 12 October 1915.

*Edith Cavell: her death by firing squad shocked many in Britain.*

Edith was the daughter of Frederick Cavell the local rector and his wife Louisa: she was the eldest of four children. She grew up with a love of nature and proved to be a talented artist. She was educated at home and then in three boarding schools in Kensington, Clevedon and Peterborough. In 1890, she took a post as governess in Brussels with the François family. Deciding to become a nurse, she was trained at the London Hospital and went on to several nursing posts in England.

She returned to Brussels in 1907 and was put in charge of a pioneer training school for nurses. She was to remain in Brussels for the rest

of her career, but made frequent visits to her mother, now a widow and living in College Road in Norwich: they often holidayed together on the north Norfolk coast.

Edith was with her mother in Norwich when war broke out. She could have stayed in England, but decided that it was her duty to return to Brussels at once. Edith wrote from Brussels to her mother in Norwich on 17 August:

> My darling Mother. Just a line - and please let me know at once if you get it — I am afraid my letters do not arrive. All is quiet at present, we live under Martial Law. And it is strange to be stopped in the street and your papers of identity examined.
>
> If you should hear the Germans are in Brussels don't be alarmed, they will only walk through as it is not a fortified town and the fighting would not take place in it; besides we are living under the Red Cross. I should be very glad of English papers but none have reached us since we left England. Two of our nurses arrived on Tuesday at 10 am having had a great deal of trouble to get through.

Brussels fell to the Germans on 20-21 August 1914. Edith's hospital looked after wounded soldiers of all nationalities, including Germans — but she took it upon herself to shelter Allied soldiers, and was part of an underground lifeline that helped them escape through enemy lines. We have the testimony of the soldiers themselves about her work:

Corporal Doman to Mrs Cavell, 22 February 1915:

> I am a wounded soldier and was taken prisoner in Belgium where I escaped from. I was passing through Brussels and your daughter kept us in hiding from the Germans for 15 days and treated us very kindly. She got us a guide to bring us through Holland and we arrived in England quite safe.

Edith must have known she was risking her life in this work. She managed to help organise the escape of about 200 soldiers, but inevitably she was caught eventually. She was arrested, tried and sentenced to death by firing squad, along with a Belgian architect

Philippe Baucq who had also helped the soldiers to freedom.  The sentence was carried out on 12 October 1915.

Paul Le Soeur (German military chaplain) has left an eyewitness account of the actual execution:

> The verdict was read.  I took Miss Cavell's hand and said in English: 'The grace of our Lord Jesus Christ and the love of God and the fellowship of the Holy Ghost be with thee, now and for ever'.  She returned the clasp of my hand and answered something to this effect: 'Tell Mr Gahan to tell my loved ones that my soul, as I hope, is saved, and that I am glad to die for my country.'  Then I led her a few steps to the pillar, to which she was loosely tied - a bandage over her eyes.  Then the sharp word of command was heard — a volley rang out — and without a sound the accused sank to the ground.
>
> A few minutes later her coffin was put into the earth, and I prayed by Edith Cavell's grave and pronounced the blessing. But when I got home, I felt sick in my soul.
>
> I can testify that the whole sad affair was carried through without the slightest hitch; that in my opinion Miss Cavell's death was instantaneous and without any pain; that, as far as I could see, all present tried to treat the accused as kindly as they possibly could.

There was an immediate outcry across the world.  The diary of Henry Rider Haggard, the well-known Norfolk novelist, records his reaction when he first heard the news on 18 October 1915:

> It seems that Miss Edith Cavell, the daughter of the late Rev F Cavell, Vicar of Swardeston near Norwich, who has been murdered at Brussels by the Germans for assisting Belgians to escape from the city, met her end bravely.  She fainted however in the presence of the firing party, whereon the officer in charge blew her brains out with his revolver.  May heaven avenge this noble woman, whose fate, perhaps, will help to bring home to the civilised world what German dominion really means.  So would our wives and daughters be dealt with if ever the Huns got a footing in England.

Another soldier whom Edith had helped, Lance-Corporal A Wood, wrote to Mrs Cavell on 18 October 1915:

I am writing in the hope of you accepting my deepest sympathy for your recent bereavement. It was with deepest regret that I read of the terrible calamity that overtook your daughter.

You will be surprised to receive this letter from me, a stranger, but had it not been for your daughter, I should have undoubtedly have suffered the same fate.

I escaped from the Germans after the Battle of Mons, and was in hiding in the vicinity of that town, when I got into communication with your daughter.

It was your daughter that arranged for me to get to Brussels, and afterwards to go from there into Holland. I was hiding in the Hospital, of which your daughter was the matron, for five days and she treated me as my own Mother would have done, and proved herself to be the very best friend I ever had.

I am not the only English soldier that your daughter befriended, there are four more in my own Regiment, besides the men of other Regiments, she helped.

I can only say she has done a great deal more for her country than most of the men who are in England at present, and although I feel the deepest sympathy for you, I am sure you will be proud to have such an heroic daughter.

Hoping you will accept this intimation of my very, very deepest regret, and thankfulness for a debt I can never repay.

Mrs Cavell also received a formal letter of condolence from the King and Queen, sent from Buckingham Palace on 23 October 1915:

By command of the King and Queen I write to assure you that the hearts of Their Majesties go out to you in your bitter sorrow: and to express their horror of the appalling deed which has robbed you of your child.

Men and women throughout the civilised world, while sympathising with you, are moved with admiration and awe at her faith and courage in death.

Edith's death was a great propaganda coup for the Allies, and was used to encourage men to enlist into the British Army to avenge her. After the war her body was returned to England and buried in Norwich Cathedral Close, while statues in her honour were erected in London and in Norwich.

Edith would not necessarily have enjoyed any of this. In her last days, while in prison, she was clear that she wanted to be remembered not as a martyr or a heroine, but simply as a nurse who did her duty. She might even have agreed with a man named 'Frank' of 9, The Market Place, Norwich, who wrote to his father in 1919: 'Well Nurse Edith Cavell is laid to rest .... She has caused a bit of work round this quarter and to mind it was all unnecessary. There are no doubt scores of other poor souls who have done just as much as she has, but no fuss has been made over them.'

Her last words are generally said to have been 'Patriotism is not enough'. In fact there are two accounts by Rev H Stirling T Gahan (chaplain of Christ Church, Brussels) of his final meeting with Edith, on the night before her execution:

Version One: In the most commonly quoted version, she said to Gahan 'They have all been very kind to me here. **But this I would say standing as I do in view of God and eternity I realise that patriotism is not enough. I must have no hatred or bitterness toward anyone.'**

Version Two has a slightly different set of words:

On the evening of Monday 11 October 1915, on returning from a visit to a friend, I found a note in pencil awaiting me.
It was from the German military chaplain, Pfarrer Le Soeur, with whom I was previously acquainted, asking me to come and see him at once that he might inform me of an Englishwoman who had not long to live and who wished to receive the Holy Communion

I went at once to his lodgings at 18 rue Berlaimont and in a short interview learned the sad news that Miss Cavell was to be shot the following morning, but that he, Pfarrer le Soeur, had obtained permission for me to visit the condemned lady in her cell that evening.

At 8.30 pm (9.30 German time) I arrived at the prison of St Gilles and, having presented my permit, was at once conducted to Miss Cavell's cell.

The brave lady had retired to rest, but was soon roused on hearing that her pastor had come, and after a few moments, presented herself at the cell door, calm and sweet in demeanour as ever, just as I had known her and seen her when last at liberty. When we were left alone she began quietly to speak of things which concerned her most and as one who saw the nearness of Eternity.

She assured me, in answer to my questions, that she trusted in the finished work of Christ for her full salvation and was fully at rest in Him.

Then she added: '**I know now that patriotism is not enough. It is not enough to love one's own people: one must love all men and hate none**'.

Edith's courage has rightly made her a legend, but she was by no means the only nurse serving abroad during the war, and risking their lives for their fellow countrymen. **Jessie Hayward** was born in 1883: her family lived at Hardley Hall, near Loddon in Norfolk. She decided on nursing as a career and trained at the Norfolk and Norwich Hospital between 1906 and 1909. As a professional nurse, she offered her services to the war effort, working in France. In 1917, she decided to volunteer to work in Salonica in Greece. She made a day-by-day record of what happened next:

Wed. May 2<sup>nd</sup> Great excitement reigns in the Camp. We hear 65 of the 48<sup>th</sup> & Matron are leaving tomorrow, on-route for Salonica. Every one rushes to the List. I am one of the number to go & am glad but for one regret, the mail is not in yet.
May 3<sup>rd</sup> Wake at 4. a.m. bundle luggage out of the tent, to be

collected by Orderlies between 4 & 5 a.m. (eventually gathered
up at 9. a.m. a mere detail) Transports arrive for us & luggage at
11. a.m. Much hand shaking & fair wells not to say tears, by
those who are left. So long. We will have tea ready for you on
arrival at S.

Jolting through the streets of Marseilles for the last time, even
the French look rather sadly after us & wave adieux.

12.30. All on board, cabins allotted, I share with three other
sisters, & as one inner cabin, is allotted to us, we secured an
electric from the Steward, who is quite a good sort. Lunch gong
sounds, & we all enjoy a good meal.

2. p.m. Life boat drill. A farce as usual.

3. p.m. Rain begins to fall, Sister Swimford & I both have violent
head aches & retire to her cabin for a few minutes absolute rest.
Feeling refreshed we sally forth to rather sadly watch our
luggage & stores being brought on board.

4.p.m. Welcome sound of Tea gong.

After tea the rain clears, have some chats with "Tommies" on
deck, 3500 on board.

6.30. Dinner. Everyone appears in clean white caps looking their
best. Matron in a new alpaca. Sister S. & I are two of the <u>chosen</u>
6 to sit at her table. (Some have honours Thrust upon them).
During dinner the ship starts. The boat is lovely beautiful
berths, lovely saloons. Everyone friendly & looking forward to
the Voyage. Some have qualms of sea sickness. "Mothersills"
taken by some stealthily. After dinner Matron gives us a private
rehearsal of what to do if we are torpedoed. We walk to our life
boat. I am to be in charge of our corridor. Life belts always to be
worn: (Some grumble).

9.p.m. On deck, watching our sailing out to Sea & leaving land
behind us. Our Japanese Destroyer well in evidence
accompanying us.

10 p.m. Retire to bed & the Captain says we may undress as we
shall be near land all-night. I have a lovely hot sea water bath.
Sleep well till 4. a.m.

May 4<sup>th</sup> The Steward calls in "just passing Monte Carlo all well".
The Men start drill on deck. I doze till 7. a.m. Dress & go up on

deck. A Tommy in <u>our</u> life boat, salutes me & smiles as if he knew me.

8-15. a.m.   Breakfast & all have a good meal, & no one feeling sea-sick! Our Cabin has been tidied, beds made my eiderdown looks so nice

9. a.m. Up on deck, the sea so blue & just flecked with white foam, here and there, the sun glorious but a fresh breeze blowing. I have a chat with my "Tommy" in the life boat, he turns out to be Pte Francis, my old patient last Xmas at Cambridge. He tells me he is on duty for 4 <u>hrs.</u> Sister Swimford & I choose chairs, & get our work & books & settle for the morning. Our V.A.Ds come along & we all have a chat & every thing seems so nice.

10. a.m.  Matron comes & insists all life belts are to be worn continually, we obey. We read the Ships news paper, just one leaf typed, we read of our gains on Western Front, also of H.M.S. *Arcadia* being torpedoed Apl 15th 150 missing. Our Senior Major comes up & has a chat, such a nice man.

10.15. A <u>bang</u> which those who heard will never forget, Sister S. & I got up & said the ship has been struck. There is no panic, every one goes to his allotted place, what white faces all around. A Scotch officer tightens my life belt (I have never seen him since) & we are to get in "Ladies first" how often I have read but never expected to hear that Cry, Pte Francis helps me in & immediately find my feet wet, but this is a mere detail. Matron & 45 of us all pushed in 3 Tommies & then the boat is lowered. I really think this is the worst moment. The Captain gives orders from the Bridge we hear there is no crew. Who will volunteer? Two Sailors come down the roap [sic]. Jack acts as skipper, we shall never forget him. Only a lad of 17, but how brave & splendid he was through out. Our boat sets out & the men from the boat give us 3 cheers! & I cannot look back. The sea seems quite rough. The Sisters help with the oar's, we are in sight of shore. My rowlock is broken so I cannot row, I wish I could, only to do something one feels better "Throw the extra oar over-board, some poor soul may be glad of it" Jack says.

The boat seems full of people, some poor girls very <u>sea</u>-sick, I

feel pretty fit at this stage. "You did not get me well at Cambridge for nothing, Sister Hayward". It seemed strange to hear my own name. Francis works hard, throws off his coat & even his life belt to work. Jack's smiling face at the rudder, cheering us all & shouting out orders. It seems a long way to shore. A second torpedo strikes our ship & an answering shot from the Destroyers. The *Transylvania* seems to be going down on one side. Many boats are now launched all round us. Why don't they pick us up? Our boat is filling with water, we start bailing out, but it seems so fruitless & the waves are so big. We throw all sacks, coats, rugs etc over board. Another bang &

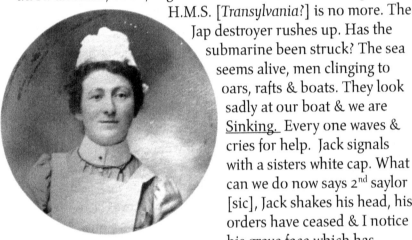

*Jessie Hayward.*

H.M.S. [*Transylvania?*] is no more. The Jap destroyer rushes up. Has the submarine been struck? The sea seems alive, men clinging to oars, rafts & boats. They look sadly at our boat & we are Sinking. Every one waves & cries for help. Jack signals with a sisters white cap. What can we do now says 2nd saylor [sic], Jack shakes his head, his orders have ceased & I notice his grave face which has smiled before. "Give me my life belt", Francis puts it on only just in time, I & all the Sisters think we shall sink with the boat. I wonder what they will think at home. A lot flashes through my mind. My life has been a useless one. God help us all. Each wave we think must be the last. Another big wave & the boat is swamped, but somehow is still floating & we are all hanging on. One V.A.D jumped out as she could swim, & is clinging to an oar behind me. I am washed out & find my-self clinging to an oar & piece of rope. At first I felt very frightened & believe I was calling out. Francis is also washed out & I still find I am next to him. He said "Hold on Sister, don't be frightened" "Hold on" "Hold tight" is the general cry. I can see some of those agonised faces now.

After a time I felt calmer but my arms were aching so I felt I must give in. Will they never come? Jack says hold on Sister a 2$^{nd}$ boat is coming to pick us up. The waves seem so big, quite over my head, the salt water makes me feel so sick. I thought of home & all my very dear ones. Life is sweet. It seems hours we were in the water, some one tried to get me back into the boat, but I could not. I could see & feel little now. A Cheer! from the distance it seemed & then some one said the destroyer was alongside. I thought my head was going to be knocked & it was a pity to be killed after all "the holding on". Two hands came down & I was pulled up first. My hair seemed caught, the rope

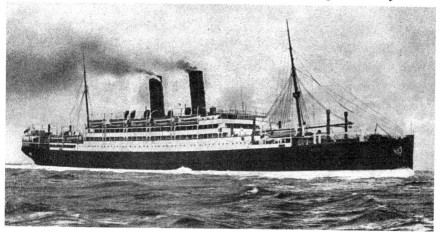

*SS Transylvania.*

ladder was there & I got one foot on. I felt the ship boards under my feet & crowds of men all around me. All went black! I knew I was lying down & some one was chafing my hands & face. A doctor was calling for brandy, it all seemed so far away "Sit up you are all right" Drink this "wine" out of a bottle. "Take her down below to the Storeroom". I was led down somehow, & oh how nice to feel the warmth. Two dear little Japs brought a towel & rubbed my hands, my teeth were chattering. I could not keep a limb still.

After this I seemed to come round & I heard it was 1.30 p.m. People all round me were being sick, but I felt quite fit & chirpy again & was able to laugh & talk. Oh the relief. Many of the sisters were undressed, but I would not let them take my things

off. Officers, Tommies & Sisters were all helping each other. It
was a strange sight.

Japs handed around wine, biscuits & water (to drink the latter
you put your mouth to the spout of the one kettle) I munched
some dry biscuits & felt all the better. At last we reached Savona.
After saying good-bye to our Japs we went up on deck. The
Destroyer seemed full of men in khaki, as at least all sorts of bits
of uniforms and the shore was crowded with Tommies. I
wondered where they had come from, but heard later, they were
off the *Transylvania* & had been brought to shore sooner than
us. I said good-bye to Francis on deck & have not seen him
since.

What a reception we had at Savona. The Cheers! We felt quite
heroines & had done nothing to deserve it. The women were
crying. We must have looked weird, some wrapped in blankets,
others in men's coats & all with wet draggled hair. (I saved two
hair pins only) An Italian took us in his car to the Hospital. I
had a Tommie with his head on my shoulder, feeling very bad
poor boy. At the Hospital an English lady met us to our joy, &
after we had again had wine poured down our throats Mrs
Rayner took us (again in cars) to her house "The Seaman's
Institute". Here we took off our soaking garments & were clad in
all sorts of queer things, I had a man's shirt & pair of socks &
trousers, a kind Italian lady came in later & took off her
petticoat & gave it to me.

Mrs Rayner gave us tea & biscuits & we left our clothes to be
dried. We did not know what had happened to the other boat at
this time, but heard later the whole 66 had been saved
Eventually 22 of us were taken to a convent, where we had every
kindness & were literally put to bed. I did not sleep a wink,
although the bed was so comfortable. I had visions of
pneumonia or pleurisy as every breath hurt so much, but it was
only bruised ribs from the life-belt "hanging on"

5<sup>th</sup> **Sat** Got up at midday, raining in torrents, borrowed clothes.
No shoes. Italian ladys [sic] visited us, brought post cards,
flowers & sweets, I felt better. Had a lovely tea party given in our
honour. Bed & slept better.

The Captain of ship died in Hospital from crushing & shock.
**6th Sunday** We went to the funeral 16 coffins what a sight.
Sunday later we were taken to tea at the Chateaus. Had a lovely
time. Went to Seaman's Institute to get my clothes. What a joy to
get them back.
**8th Mon** Went into Savona had our photos taken. 6. p.m. left
Savona What a send off we had. Spent night in the train once
more.
**9th Tues** Back at Marseilles. Nurses Camp. Sisters from home.
Had a bath. Sleep in tent once more.
**10th Wed** Hear we are to return to England to re-equip. Cheer
oh! Concert in Evening.
**11th Thursday** Have tea in town
**12th Fri** Quiet day in camp very hot
**13th Sat** Hear we are leaving Camp Sunday or Mon
**14th Sun** Service 9-30 Whisper goes round in the middle
"leaving" in 30 minutes. Have soon packed & are once more in
transports.
**15th Mon** In train all day very very hot & tired. Wrote this diary
in the evening out of sheer ennui.
**16th Tues** Cold English weather, "one off day" Porridge & eggs
for breakfast (I dislike both) & not enough bread to go round.
Arrive at Havre 4. p.m. Said good-bye to our friends on the
train. Looked over the Stationary Hospital, where they gave us a
nice tea of bully beef & Cake.
6.30 Embarked. Sailing out at 10. p.m. None of us slept very well
& clung to our life belts, although the steward said they were not
necessary!
**17th Wed** Arrived at Southampton at 8. Can hardly believe I am
in dear old England again, Or has it been a dream?
We go up to town looking more funny than ever amongst other
people. Spend the day shopping. Catch the 5-20 from Liverpool
St 11 p.m. at Hardley once more. Father & Min meet me on the
door stop. How lovely to be really home, I am very thankful.
Go to bed & sleep well & that's the end I must try & write
another diary if ever I get out to the East, but I hope it won't be
so exciting as this.

There were sixty nurses on board the *Transylvania*. All were saved, but over 400 soldiers and members of the crew lost their lives in the disaster.

Jessie's story is known because she wrote it down: her account is now in the Norfolk Record Office. Other Norfolk nurses went through dramatic and life-changing experiences in the war, but much less is known about them because they did not record their experiences, Two others honoured for their courage were Mabel Chittock and Grace Corder, both at one time pupils at Norwich High School for Girls. **Mabel Chittock**, born in 1872, was the daughter of John Carsey Chittock and his wife Rachel. Chittock was a solicitor, based at Bank Plain, Norwich: the family lived at The Grange, Eaton. By 1911, Mabel was a professional nurse, working in London. During the First World War, she served at the great British military base at Étaples in France, and won the Military Medal 'for gallantry and devotion to duty during an enemy air raid. She displayed great presence of mind and instilled courage and confidence throughout a very trying time!' Mabel never married and moved to Felsted Essex: however, she died at The Grove, Catton Grove Road, in Norwich on 16 May 1942.

**Grace Octavia Corder**, born in 1875, was the daughter of Octavius and Margaretta Corder. Her father was a chemist, with a shop in London Street, Norwich. The family home was in Thorpe Saint Andrew, outside the city. She served in many hospitals across the Mediterranean areas of conflict, as recorded in the School Magazine: 'Grace Corder, now Matron of the 81st General in France, was mentioned in despatches for services in Egypt in 1916 and in connection with the sinking of a Hospital Ship in 1918: received the French 'Medaille d'Honneur des Epidemies en Vermeil' 1917 for work in connection with an explosion on a troopship, and the English Royal Red Cross 1st Class for services in Malta 1918'. Grace remained single, living at Brundall, Norfolk, in later life: she died there in 1962.

# 3

# Mary Sheepshanks

**Mary Sheepshanks** was born on 25th October 1872 at Bilton Vicarage, near Harrogate, North Yorkshire, the second of the thirteen surviving children of John Sheepshanks and his wife, Margaret, formerly Ryott (four more died in infancy). Mary later wrote about her mother: "The entire lack of the element of pleasure in our home-life was no doubt largely due to the ceaseless worry and nervous strain of her incessant child bearing ... my Mother was swamped by babies."

John Sheepshanks had had an adventurous career for a clergyman. He had worked in America, and afterwards travelled literally around the world. He became vicar of Bilton in 1868. In 1873, in Mary's first year, he was appointed vicar of St Margaret's Anfield, where the family lived for twenty years, so this is where Mary grew up: the family were at Walton on the Hill at the time of both the 1881 and 1891 censuses. Conditions in the vicarage were austere to say the least, but she was able to attend Liverpool High School for Girls, one of the new schools intended to further the education of girls so that they could take up professional careers. In 1889, aged seventeen, she was sent to Germany to learn the language, living first at Kassel and later at Potsdam.

Mary went on to Newnham College, Cambridge, in 1891, made new friends and was opened to new ideas. She studied medieval and modern languages, and while still a student taught adult literacy classes in Barnwell. She became a friend of Bertrand Russell.

In 1893, while Mary was at Cambridge, John Sheepshanks became Bishop of Norwich and he and his family moved into the Bishop's Palace, which was to be their home for the next seventeen years.

*Mary Sheepshanks.*

Sheepshanks' youngest daughter remembered it with great dislike: 'vast bare staircases, long, dark corridors, very little sun, and in winter the most piercing cold were its main characteristics'. The stairs were covered with linoleum rather than carpet. Mary was twenty years old when her father became Bishop, so this would not have been a formative time in her life, but no doubt the homes in which she was brought up had the same flavour.

If Mary wanted to, she could have made many family visits to Norwich from Cambridge. However, at some point in her university career, she was 'disowned' by her father, who told her NOT to come home during her university vacations! This was because of her aggressively atheistic views — she is said to have marched outside her father's palace in Norwich when he was entertaining royalty: she carried a placard stating simply: THERE IS NO GOD. Another version of the story says she distributed atheist tracts to the royal guests!

In 1895, Mary joined the Women's University Settlement, later the Blackfriars Settlement in Southwark, London. Two years later, she became vice-principal of Morley College for Working Men and Women: she had begun working there as a voluntary teacher some years earlier. One of her claims to fame is that while there she recruited Virginia Woolf to teach evening history classes! At the time of the 1901 census, she was living at Cowley Street, Westminster, and was described as 'school teacher (languages)'.

She became a member of the WSPU, but disliked the level of violence and became a supporter of the NUWSS instead. In 1913 she went on a speaking tour in Europe, promoting votes for women. This international aspect of the suffrage movement is often forgotten, but Mary embraced it with enthusiasm. The International Woman Suffrage Alliance had

been founded in 1902. In 1913, Mary became its secretary, working at its Headquarters in London, and editor of its international magazine, *Jus Suffragii* ['the law of suffrage']. This was published in English and French. Even before war broke out, the magazine published an article by Frances Hallowes *Women and War: an appeal to the women of all nations.* This urged women to join in a crusade for peace: Mary Sheepshanks had it reprinted as a pamphlet and sold it for two pence so that it would have a wide circulation.

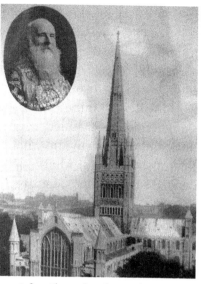

*John Sheepshanks, Bishop of Norwich: his daughter Mary was a suffrage worker and pacifist.*

The IWSA held its annual conference in London at the end of July 1914, when the tensions between the Great Powers were building up. The conference drafted an International Manifesto of Women:

> Powerless though we are politically, we call upon the governments and powers of our several countries to avert the threatened unparalleled disaster.... We women of twenty-six countries, having banded ourselves together in the International Women's Suffrage Alliance with the object of obtaining the political means of sharing with men the power which shapes fate of nations, appeal to you to leave untried no method of conciliation or arbitration for arranging international differences which may help to avoid deluging half the civilised world in blood.

The manifesto was delivered to the Foreign Secretary, and then to every ambassador in London. Of course, it had no effect: war was declared on 4 August. The manifesto was published in the next edition of *Jus Suffragii*, published on 1 September, by which time the war had already been going for three weeks. *Jus Suffragii* had a clear take on

the outbreak of war: 'Each nation is convinced that it is fighting in self-defence, and each in self-defence hastens to self-destruction. The military authorities declare that the defender must be the aggressor, so armies rush to invade neighbouring countries in pure defence of their own hearth and home, and, as each Government assures the world, with no ambition to aggrandise itself. Thousands of men are slaughtered or crippled ... art, industry, social reform, are thrown back and destroyed; and what gain will anyone have in the end? In all this orgy of blood, what is left of the internationalism which met in congresses, socialist, feminist, pacifist, and boasted of the coming era of peace and amity. The men are fighting; what are the women doing? They are, as is the lot of women, binding up the wounds that men have made.' Mary Sheepshanks also called for a negotiated peace and called for an end to the arms race: 'Armaments must be drastically reduced and abolished, and their place taken by an international police force. Instead of two great Alliances pitted against each other, we must have a true Concert of Europe. Peace must be on generous, unvindictive lines, satisfying legitimate national needs, leaving no cause for resentment such as to lead to another war.'

Mary lived throughout the war at 1, Barton Street, Westminster, sharing the flat with two other feminists, Rosika Schwimmer from Hungary, and Catharine Marshall, later important in the No-Conscription Fellowship. Their landlady was not always happy — when they wrote a 'peace' letter to the *Pall Mall Gazette*, she tore it up saying 'You can't use my address for this'!

Mary was not one to sit writing copy for a newspaper when real action was needed. She went to the Netherlands after the fall of Antwerp, to help with the many thousands of Belgian refugees there. She and a friend, Chrystal Macmillan, bought £200 worth of food from London and took it across the Channel to Flushing. They were shocked by the conditions. In her unpublished autobiography, she wrote: 'Hundreds of women and children were on barges, many without warm clothing and often clutching some useless thing such as a bird-cage. That was the first wave of the tragic flood of refugees that has swept across large parts of the world ever since, involving broken homes and broken lives.' The two women appealed for Britain to admit the many Belgian refugees when Germany invaded that country in 1914.

Mary joined the pacifist organisation, the Union of Democratic Control, one of whose leaders was her old friend Bertrand Russell. She played a major role in the Hague International Women's Conference of April 1915, which was given publicity in her paper. The January 1915 issue of *Jus Suffragii* included an 'Open Christmas Letter' addressed: 'To the women of Germany and Austria'. This was signed by one hundred British women. Many of them were Quakers. Others included former suffragettes now committed to pacifism, such as Maude Royden, Helena Swanwick and Sylvia Pankhurst. Other signatories included Independent Labour Party women like Margaret Bondfield (late to become Britain's first cabinet minister) and Katherine Glasier: German and Austrian women responded, and on 1 March 1915, *Jus Suffragii* published a letter by Dutch pacifist Aletta Jacobs, announcing an International Congress of Women, which was to be held at The Hague on 28 April 1915. No fewer than 180 women from England applied to go, including Mary Sheepshanks, but the Government made things difficult. The Home Secretary, Reginald McKenna at first refused to issue any passports to the women, later relenting under pressure and agreeing to allow twenty-four carefully selected women to go: Mary was on this list. However, Winston Churchill at the Admiralty declared the Channel and North Sea a military zone, and none of the women were allowed to cross the Channel: many of the women got as far as Tilbury, but had to sit on the dock watching the ship on which their passages were booked lying at anchor. Just three women from England attended the Conference, two, Katherine Courteney and Chrystal Macmillan, being already in Europe and a third, Emmeline Pethick Lawrence travelling from America. Mary published the Conference debates in the *Jus Sufragii*. Its resolutions were very similar to President Woodrow Wilson's later Fourteen Points, on which they may have had some influence: Wilson was acquainted with some of the American conference delegates.

*Jus Suffragii* continued to be published throughout the war, and managed to get into countries on both sides. Some people, including Millicent Fawcett, thought that Mary should be making the magazine one dedicated to the cause of women's suffrage rather than the cause of pacifism, but Mary continued with her pacifist policy.

Mary, like so many women, including Dorothy Jewson, suffered

personal tragedy in the war: her brother William was killed in action. Furthermore, another brother, John, decided that her attitudes made her nothing less than a traitor – he never saw or spoke to her again.

At first, the magazine welcomed the Russian Revolution, Mary writing in April 1917: 'Women suffragists all over the world will welcome the liberation of the hundreds of millions of inhabitants of that vast empire'. The Russian Revolution appeared to offer universal suffrage, but, those hoping for advancement in the rights of women in that country were soon disillusioned.

After the war, people in Europe were starving because of the Allied blockade, which continued even after the Armistice of November 1918. The position was especially bad in Berlin and Vienna: children were dying of starvation, and those who managed to survive suffered from tuberculosis and rickets. One report noted that 'Children's bones were like rubber. Clothing was utterly lacking. In the hospitals there was nothing but bandages.' In January 1919 came the first meeting of a newly-formed Fight the Famine Council. The founders were Dorothy Buxton and Eglantyne Jebb. Eglantyne had earlier been fined for handing out in Trafalgar Square a leaflet headed: "A Starving Baby and Our Blockade has Caused This". This drew attention to the plight of children on the losing side of the First World War. Mary, typically, went into action: she resigned her position with *Jus Suffragii* to become the Council's secretary. The Council's efforts on behalf of the starving led directly to the foundation of the Save the Children Fund in May 1919: this did good work in Austria and continues to help children in need across the world today.

Mary continued to be involved in social concerns all her life. She was one of twenty-six English women present at an International Woman's Conference in Zurich in 1919, which led to the foundation of the Women's International League for Peace and Freedom, Mary became its secretary in 1927: however, she resigned after three years as she thought the League had been taken over by Communist sympathisers. In 1931, Mary went to Poland, and reported on the oppression of Ukrainian nationals in Galicia by the Polish government of Marshal Pilsudski. In the later thirties, she was part of a group sending medical help to Republicans fighting in the Spanish Civil War: she also helped find homes in Britain for Basque children refugees. Mary renounced

her lifetime pacifism because of Hitler's aggression. However, she took German and Austrian refugees into her own home during the war and opposed military 'excesses', like blanket bombing of German cities and the use of the atomic bomb on Japan. In old age she lived at 15, Thurlow Road, Hampstead. Crippled with arthritis and faced with having to move into a care home, she asserted her independence to the last: on 21 January 1960, she took her own life. She was 86 years old.

# 4

# Ethel Williams

**Ethel Mary Nucella Williams** was born and baptised in Cromer, Norfolk, in 1863, the daughter of Charles and Mary Williams: Charles Williams is described as a 'country gentleman' in the baptism register. The family do not appear to have been in Cromer long, but the remained in Norfolk. Charles had been living at Caversham in Oxfordshire at the time of the 1861 census, and he does not appear in the Cromer voters' registers for 1862 or 1863. They had moved to a house in The Street, Caston, in Norfolk by 1871, by which time they had two more children, Mabel and Gerard: Gerard was born in Caston in 1868, so they had presumably moved away from Cromer by that date. The family was a wealthy one: Charles is described a 'landowner' in the 1871 census, and they had four live-in servants.

Ethel attended the Norwich High School for Girls between 1879 and 1882, staying at a house in nearby Theatre Street. She went on to Newnham College, Cambridge, but did not take a degree. She went to Vienna and Paris studying medicine, eventually graduating in London in 1895. After working for a short time among the London poor, she moved to Newcastle in 1896, but returned briefly to Cambridge to study for a diploma in public health. She was the first female doctor in Newcastle, and devoted herself to the poor, especially children: she personally paid for the daily supply of milk for poor babies. She was one of the first women on Newcastle School Board, and her worth was recognised when she was co-opted onto Newcastle Education Committee when School Boards were abolished in 1902. She was also said to be the first woman in the north of England to drive a motor car!

Ethel became a well-known figure in the northeast, speaking, for example at a Charity Organisation Conference in Leeds in 1910: she

Ethel Williams' baptism entry, Cromer: the baptism was performed by Frederic Fitch.

spoke of the desirability of keeping families together wherever 'the home was worth preserving', rather than splitting up the family unit. She was also a speaker at the Durham Miners' Gala in July 1914.

Ethel was dedicated to the cause of obtaining the vote for women. She was a member of the NUWSS, becoming one of the group's leaders in the north east alongside her life-long companion Frances Hardcastle. She was at the 'mud march' in London in 1907, one of the first of the great protest marches of the suffragette movement, and she frequently carried a placard in the High Street in Newcastle. She also practised passive resistance, refusing to pay her income tax as women were not represented in Parliament where decisions about tax were made.

Ethel was a committed pacifist. When the NUWSS supported the war in 1914, she broke with the group. She applied for a passport to attend the Women's Congress in The Hague in 1915, but she was one of the many women whose applications were turned down by the Home Office. She was a member of the Union of Democratic Control, and also of the No Conscription Fellowship, chairing its north-east convention in October 1916. As secretary of the Newcastle Soldiers' and Workers' Council, she organised anti-war demonstrations in the city in 1917 and 1918. As well as all this, she continued to be very active in medicine, founding the Northern Women's Hospital in 1917.

After the war she took up the cause of the children who were suffering privations because of the effects of the allied blockade of their former

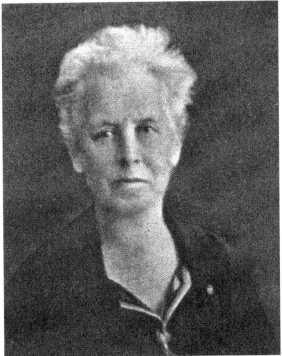

*Ethel Williiams, suffrage & peace campaigner.*

enemies. She was in Vienna in May and June 1919 and produced a report: 'In the poorer parts of Vienna I saw no children of two and three walking the streets at all: those I saw were being carried by their mothers, miserable little morsels of humanity .... There was no playing, no laughing, no child was running about. Life for them had become a thing to be endured.'

She returned to England in June and gave an address on 'Starvation in Europe' at Caxton Hall, Westminster. The event was organised by the Women's International League and Jane Addams also spoke to the meeting. The Christmas term 1919 edition of the *Norwich High School Magazine* noted her achievement: 'Dr Ethel Williams has lately been investigating the conditions in Vienna (where she formerly studied medicine), especially in relation to the health of the children as affected by the war, and has lectured on the subject on her return.'

She attended the third international Congress of the Women's International League for Peace and Freedom in Vienna in 1921.

Ethel retired from general practice in 1926, to devote her life to the twin causes of child poverty and pacifism. When she came back to Norwich High School in 1935, she listed her current achievements: she was the only woman on the Senate of Durham University, she was President of the Federation of Medical Women, and she was Vice-President of the Northern Federation of Women's Institutes. She was also a Justice of the Peace, specialising in cases involving children.

Ethel helped provide for Jewish child refugees before the Second World War, and during the war went on a course at a Hammersmith hospital so that she could help civilian casualties — she was in her eighties! After the war, she supported the United Nations Association.

Ethel died at Low Bridges, Stockfield, on 29 January 1948 at the age of 85. She was buried at Hindley church, with a memorial service at St George's Church, Jesmond. A Newcastle journal wrote: 'Essentially feminine in her cultural interests and recreations, she yet had a tough streak in her character. She was always willing to lead where others faltered and pull out the extra ounce of strength'. The Ethel Williams' Halls of Residence at Newcastle University were opened in her memory in 1950.

5

# Women on Norfolk war memorials

Almost 12,000 Norfolk men were killed in action during the First World War. In the decade after the war, memorials were erected in almost every town and village to these men. A small number of women serving in the war were also killed in action, whether in the Armed Forces (in which women could serve during this war for the first time), serving as nurses, or in other ways. I know of just seven women recorded on Norfolk war memorials, and their stories show in how many different ways a woman could serve her country.

## Violet Elizabeth Davey: Royal Air Force.

Violet was born in North Elmham in 1894. Her parents were Charles and Mary Davey. By the time of the 1901 census, the family were living at Stanfield where Charles was a teamster (that is, he looked after the horses on a farm). Violet became a domestic servant: in 1911 she was a live-in housemaid at The Hall, Caston. By the time of the war her father was back in North Elmham, living at Stone Terrace.

When the First World War broke out women were recruited to work in the Armed Forces, both the Army and the Navy. They also worked on air stations belonging to the Royal Flying Corps and the Royal Naval Air Service. When these merged in 1918 to form the Royal Air Force a

Women's Royal Air Force was established on 1 April 1918. Upper-class recruits were officers, the rest were known as 'Members'. Most worked as clerks, others trained either in technical skills to be welders or fitters, or in more general skills like driving.

Violet was based at South Carlton Aerodrome in Lincolnshire. She caught pneumonia and died on 13 March 1919: she was twenty-five years old. She was brought back to North Elmham and buried in the churchyard on 18 March 1919. She is listed on the war memorial in the church (her name is a later addition), and her grave is maintained by the Commonwealth War Graves Commission.

## Edith Cavell, Mary Rodwell, Mary Matthews & Susannah Hall: nurses

Edith's story is told in another chapter. Many nurses went abroad following the British Army: they were exposed to great risk and some paid the ultimate price. About 200 nurses were killed on active service in the war, most from air raids or when their ships were torpedoed, others from disease, especially dysentery and influenza.

*Edith Cavell is remembered at Swardeston.*

Mary Rodwell was a staff nurse who served in France. She was on the Hospital Ship *Anglia* on 17 November 1915, helping to look after wounded soldiers being brought back from France. The ship struck a mine and Mary was among those drowned. She is remembered on the war memorial at her home village, Ditchingham, and also on the Hollybrook memorial, Southampton.

Mary Maria Matthews was the daughter of Walter and Ellen Matthews of Coltishall Road, Buxton. She was also a nurse serving in France. She died there on 17 February 1919, aged 28  She is buried in Étaples Military Cemetery, France.

Susannah Hall was born in Reedham in 1889 and, like her two younger sisters, volunteered for service in Queen Mary's Army Auxiliary Corps. She served as a cook in D Company QMAAC in Romford and Folkestone before embarking for France in September 1918. She survived the war but was a victim of the influenza epidemic and died, at the age of 30, on 23rd March 1919. She is buried at Terlincthun British Cemetery at Wimille, France.

In 1995, at the direction of Reedham Parish Council, Susannah's name was added to the Memorial in time for that year's Armistice Day Service'.

## Blanche Garman: the Women's Land Army

People think of women working in the Land Army on farms as a Second World War activity, but it happened in the First World War as well. There were many women working on Norfolk farms, freeing up men for the front. One of these was Blanche Garman, daughter of William and Elizabeth Garman of Martham. Her brother was killed on the western Front, and she worked on a farm despite suffering from anaemia. In the spring of 1919, she was driving a tractor which suddenly caught fire: the shock resulted in a fatal heart attack. Blanche is buried in Martham churchyard, and is also remembered, alongside her brother, on the Martham war memorial.

Women remembered: Blanche Garman's name on the Martham war memorial.

## Grace Bolton: munitions worker

Gracia Bolton (usually known as Grace) was born in Beeston next Mileham on 31 July 1898. She was the daughter of Edward Bolton

and his (first) wife Mary. Her two older brothers joined the Army and Grace wanted to play her role: she took up work in munitions. Many women and girls took this path. It was difficult and dangerous work: the chemicals turned the skin of the workers orange-yellow, so that they were often known as 'Canary Girls'. There was also great danger in working with so many high explosives.

There were many shell factories in Britain, including one in Norwich, but Grace worked at Chilwell in Nottingham shire. Opened in 1915, the factory's purpose was to fill shell casings (manufactured elsewhere and brought in by railway) with an explosive mixture that included TNT. It was an enormous enterprise, employing 6,000 people, mostly women. The shifts were long, twelve hours on normal days, eighteen hours at weekends. On Saturday 1 July 1918, she began her shift at 6 pm. At 7.10 pm there was an enormous explosion: the Mixing House and two of the three Milling Buildings were destroyed. One hundred and thirty four people were killed: the bodies of 102 of them were so mangled that they could not be identified. Grace was one of them: she was just nineteen years old. Despite this tragedy, the work went on at Chilwell. Within a month of the devastating explosion, the factory achieved its highest weekly output. By the end of the war, the Chilwell factory had filled just over 19 million shells. Due to wartime reporting restrictions

*'Pro-war' women, Norwich Tank Week, 1918. They include Lucy Bignold (speaking), Gertrude Mary Wise (third left), Lady Suffield (extreme right).*

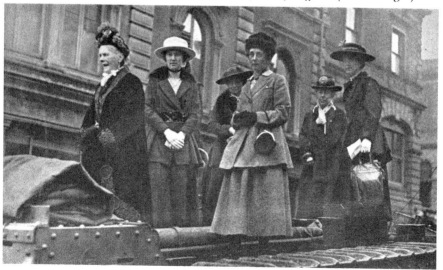

the explosion, like several other munitions factory explosions, received little attention in the press. A memorial was unveiled on the site in 1919, but as the site was, and still is, an Army base, it was not accessible to the public. Grace is also remembered on the village memorial at Beeston.

There were many other deaths in munition factories, including two enormous explosions with very heavy fatalities: 116 were killed at Faversham, Kent, on 1 January 1916 and 73 at Silvertown, London, on 19 January 1917. There may well have been Norfolk women killed in these disasters, but Grace is the only fatality from a munitions factory explosion known to be recorded on a Norfolk war memorial.

Norfolk was the part of England to experience air raids in which men and women were killed, the start of a whole new kind of warfare. Two airships raided the Norfolk coastal towns on the night of 19 January, 1915. One dropped bombs over Yarmouth at about 8.30 pm. Two people were killed, including **Martha Taylor**, aged 72, who lived with her sister at Drake's Buildings. Martha is buried at Caister cemetery. The other airship dropped some bombs along the north Norfolk coast, and finally, about two hours later, attacked King's Lynn. Again, two people were killed, including **Alice Gazely**, aged 26. Alice was an especially tragic case: her husband, Percy, had been killed in the fighting in France on 27 October 1914: he was with the Rifle Brigade.

Percy Gazely was buried in France, Alice in the Hardwick cemetery in Lynn. Percy's name appears on the Lynn war memorial but Alice's does not: victims of air raids were not then considered worthy to be on the local memorial. This had changed by the Second World War: in Yarmouth, for example the air raid victims of this war *are* included on the memorial. Another change is in the number of women in the armed forces and thus exposed to danger. In two incidents just two months apart in 1943, 34 young servicewomen (eight Wrens and 26 ATS girls) were killed in Yarmouth alone: from small beginnings in the First World War, women were now playing their full part in the war.

# 6

# The Colman sisters & other politicians

Even before the First World War had ended, women were meeting together to consolidate their achievements and to push further. The local branch of the National Council of Women workers was founded in 1918. The meetings were held in the Norwich Girls' High School, and the headmistress, Miss Wise was chairman of the council. Lady Suffield was president. Others involved included Helen Colman, her sister Mrs James Stuart, Mabel Clarkson, Mrs Sheepshanks (mother of Mary Sheepshanks), Violet Jewson (a doctor, cousin of Dorothy Jewson), and Margaret Pillow. One of their concerns was to push for an increase in the numbers of women in power at all levels. At the opening meeting Lady Suffield said that 'the war was exercising a disintegrating effect. Our old landmarks were being swept way: women had to prepare themselves to face a new world, and above all to help the children…. She believed that out of this terrible war a new England would arise, and that the women of Norfolk and Norwich would bear a share in the coming changes.' The group then agreed to push for more women candidates – of all parties – at the Norwich city council elections to be held in November 1919 to join Mabel Clarkson, already a councillor. In the event, **Alice Bloom** and **Laura Stuart (formerly Colman)** were elected, so Norwich no longer had just one woman on its council.

The County Council came next. **Lady Suffield, born Evelyn Louise Wilson-Patten**, was the wife of Charles Harbord, sixth Baron Suffield of Gunton Hall, Norfolk. During the war she helped run a War Hospital Supply Depot, providing dressings and other equipment

to hospitals at home and abroad. In 1920, she was elected county councillor for Cromer, the first woman on Norfolk County Council. Progress *was* being made, however slowly.

The most well-known women in the Norwich political world in the first decades of the twentieth century, were the three Colman sisters — **Laura (later Laura Stuart), Ethel and Helen Colman**. They were children of Jeremiah James Colman (1830-1898), head of the well-known Colman's Mustard business, and his wife Caroline (formerly Cozens-Hardy).

Laura was the eldest, born at Carrow House in Norwich on 31 July 1859. She was educated at Laleham School, Clapham Park, going on to Newnham College, Cambridge. Ethel Mary Colman was born on 12 February 1863, her sister Helen two years later. Both went to Laleham but did not go on to university.

Laura married James Stuart, Professor of Mathematics at Cambridge University, at Princes Street Congregational Chapel on 16 July 1890: Stuart died in October 1913. Laura was one of the first women on Norwich City Council, serving on its Education, Health, Housing and Maternity and Child Welfare Committees. Her many other activities are summed up in the *Carrow Works Magazine*:

She was one of the secretaries of the Norfolk and Norwich branch of the Royal Society for the Prevention of Cruelty to Animals, and she was a Branch representative on its Central Council. She was a member of the Council of the British and Foreign Schools Society, and served on the Committee which administers the Stockwell training College for teachers. She was also interested in other Societies, including some that deal especially with the interests of women.

Mrs Stuart took her full share in war work. She was one of the most active members of the Norfolk and Norwich Branch of the Voluntary War Work Association, of which she was one of its secretaries. She was anxious to do all she could for the sick and wounded soldiers during their time spent in the local Hospitals, and many of them doubtless still remember being welcomed by her at her home at Carrow Abbey.'

She was very religious, having lifelong associations with Prince's Street Chapel: she was the first woman member to be raised to the office of deacon.

In one wartime speech she summed up her views on the 'woman

question': 'Strong in faith, wise in action, tolerant in reason, may the women of our land play their part in the national life.'

In 1918, Laura was given an O.B.E. for her war work. She was appointed as Norwich's first ever female Justice of the Peace in September 1920: it was only in 1919 that women were able to become Justices of the Peace, so she must have been one of the first women in Britain to undertake this role. However, only two months after this appointment, Laura died at Carrow Abbey, on 4 November 1920, after a few weeks' illness; she was sixty-one. Her funeral was described in the *Eastern Daily*

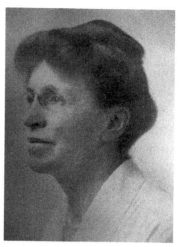

*Laura Stuart, born Laura Colman.*

*Press*: 'The profound sense of public loss which Norwich has sustained in the death of Mrs James Stuart, found expression on the occasion of her funeral. There was a great gathering of people associated with her in the private and official relations of a singularly active life; and the general public showed themselves interested in a most significant degree.' She was buried in the family plot in the Rosary Cemetery in Norwich.

Laura had already bought land in Recorder Road, Norwich, planning to give it to the city as a memorial public park to her husband. Her death prevented her carrying this out, but the project was brought to completion by her sisters: Ethel Colman formally opened the James Stuart Garden on 19th July 1922. The Lord Mayor said in a formal opening speech: 'We in Norwich recall with gratitude and pride the splendid qualities of citizenship shown by her [Laura]. We remember the zeal with which we served the city. She was intensely loyal to its best traditions, and freely placed at its disposal her gifts of mind and judgement, and a great deal of her leisure.'

All three Colman sisters were strong supporters of obtaining the vote for women. They did not belong to Emmeline Pankhurst's Women's Social and Political Union, because they disapproved of the way its members were prepared to act illegally. Instead, the Colmans were key figures in the Norwich branch of the National Union of Women's

Suffrage Societies: Laura was President and Ethel and Helen two of the Vice Presidents. Millicent Fawcett, the leader of the NUWSS came to Norwich for a meeting on 29 January 1912. The meeting was held at the Agricultural Hall; Laura was chairman of the meeting and Ethel was present. Millicent said in her speech that to 'leave out half the race was virtually to stultify every argument used in favour of representative Government. The object of all suffrage societies was to remedy that omission, to bring women into the constitution, to give them a share in the representative system of the country. The suffragists had varied widely in their methods. The methods of the NUWSS were persuasion, education, writing to the Press and magazines, addressing public meetings, and pointing out wherever possible that the enfranchisement of women would be not only for the good of women but for the good of the whole community.'

*Ethel Colman, Britain's first woman Lord Mayor.*

Ethel was very active in all sorts of field in the city, especially in adult education. She worked with Helen on many practical projects, such as the building known as Stuart Court. The 1912 floods in Norwich had drawn public attention to the appalling conditions in which many Norwich people were living. Ethel and Helen at once determined to build a block of modern houses which could be let out to the deserving poor at very reasonable rents: the final design was for 22 houses in one large block, to be rented at between 2s. 6d. and 3s. 6d. a week according to size: each house had a bath, by no means universal at that time. James Stuart took a great interest in their plans. He died in 1913 and when the project was finally completed in 1915, Ethel and Helen decided to

call it Stuart Court in his honour. The whole project was a gift by the two sisters to Norwich: the rents did not go to them but to the city to be used for 'charitable purposes'.

In 1923 came the event for which Ethel has gone down in history; Norwich city council chose her to be the Lord Mayor for the year, the first time anywhere in Britain that a woman had been elected to this high office. *Carrow Works Magazine* summed up the excitement:

> The announcement which was made on the 31st October last
> [1923] that Miss Ethel Mary Colman of Carrow Abbey had
> consented to become the Lord mayor of Norwich for the
> ensuing municipal year gave unbounded pleasure to the many
> friends and satisfaction to the Citizens generally because of
> the intimate association of her family with the civic life of the
> city, and as an indication of the accepted recognition of the
> equality now existing between the sexes in matters public. The
> appointment created a precedent, for though women have
> occupied the position of mayor in many of the towns and
> cities of this country, no woman had previously been elected
> to the higher dignity of a Lord Mayor. The interest which the
> incident aroused is evidenced in the fact that the news of her
> consent to take office was promptly cabled across the Atlantic
> and appeared in an American paper of the same date, viz.
> 31st October — the New York Times publishing her portrait in
> its Sunday edition of the 2nd December last. Miss Colman's
> qualifications for the office were referred to in our local paper as
> being — 'a clear and forceful speaker, a business like Chairman
> with a close grasp of detail, whilst her many activities have
> brought her closely in touch with all classes of Citizens' — an
> opinion with which all who know the Lord Mayor will be in
> hearty accord.

During her year as Lord Mayor, Ethel was keen on boosting adult education. Under her guidance, the Annual Meeting of the Norwich University Extension Society was held at Norwich Guildhall on 8 April 1924. Ethel gave the keynote speech:

> I can claim to have had a long connection with the movement,
> because as a Girl I attended Mr Mainwaring Brown's lectures in

1877. And later on, after leaving School, I attended the various courses of lectures and used to work hard at writing the weekly papers, on five occasions taking the examinations at the end of the courses and gaining the certificates. Of course I could not answer these examination questions if they were presented to me now, but none the less, I know that the work I did in preparing for them has been of lasting good to me.

As Ethel was unmarried, her sister Helen acted as her consort for the year. After her year as lord mayor, Ethel retired from civic office. However, she returned in 1927 to act as deputy to Herbert Witard when he became the first lord mayor who was a member of the Labour Party — and who had been a leader of the anti-war movement in Norwich during the First World War.

Another lasting contribution of the Colman sisters to Norwich was to save the building now known as Cinema City. This was the house of the Suckling family from the mid-1500s. It was in a very bad state by the early 20<sup>th</sup> century: in 1923, Ethel and Helen Colman bought it intending to restore it and present it to the public. They were given several original furnishings which had been held elsewhere for centuries, including the fireplace, oak panelling and an oak door. Stuart Hall, intended as a public hall holding around 450 people, was built on waste land to the east in 1925. When the work was complete, the sisters handed the building to the city of Norwich, to be used 'for the advancement of education in its widest and most comprehensive sense'. A plaque was put up, reading:

> In remembrance of Laura Elizabeth Stuart of Carrow Abbey,
> Norwich who greatly loved the true and beautiful and ever
> seeking after them found her highest joy in service this old and
> historic Suckling House and the new Stuart Hall are given by
> her sisters Ethel Mary and Helen Caroline Colman to the city in
> which she was proud to be a citizen, 1925.

The Colman sisters lived all their lives in just two houses, Carrow Abbey and the neighbouring Carrow House. All three were born in Carrow House. Laura moved into Carrow Abbey when she married, and died there. Her two sisters then moved into the Abbey. Helen

died there on 21 August 1947, Ethel on 23 November 1948. The three are all buried in the Colman family plot in the Rosary cemetery, Norwich

When Stuart Gardens was formally opened, the Lord Mayor called Helen Colman the first woman on Norwich City Council. This was an error on his part: the first woman on the Council was actually Mabel Clarkson, as we have seen. Mabel continued on the council as a Liberal after the war, but moved to the Labour Party in 1925. She stood unsuccessfully for Labour in Heigham ward that year, and was elected for the same ward in 1926. In 1928, she was the first woman to become City Sheriff. Two years later, she became the City's second female Lord Mayor. She had a radical view of the role of Norwich's first citizen, wanting to cut down on 'those outside engagements which have so increased and multiplied of late years' and devote her time to what she saw as the key issues —'unemployment, housing, slum-clearing, education and health'.

Mabel retired from public life in 1948, and died on 20 March 1950. The *Eastern Evening News* wrote of her; 'the public life in Norwich was the poorer when Mabel Clarkson left it. It is not given to many women, or men for that matter, to achieve such an enduring place in the history of their city.'

Women were now not just voting in Parliamentary elections, but actually becoming Members of Parliament for the first time ever. While Ethel was Lord Mayor, Dorothy Jewson was elected MP for Norwich the first female Member of Parliament in East Anglia. She was elected in 1923, but defeated in the general election of the following year. She

*Lucy Noel Buxton, campaigning in north Norfolk, 1930.*

*Lucy Noel Buxton, perhaps hoping to influence the next generation of voters in north Norfolk, 1930.*

was followed in the field by **Lady Noel Buxton**. Lady Buxton was born **Lucy Burn** in Winchester in 1888. While campaigning for a Conservative candidate, she met and fell in love with Noel Buxton, who was standing as a Liberal: later both moved to the Labour Party! Noel Buxton was MP for North Norfolk. He was made a lord in 1930 and his wife was selected as Labour candidate in the subsequent by-election: she won by just 179 votes. She was defeated at the general election in the following year, but became an MP again in 1945, this time for Norwich. She retired from politics in 1950 and died in Essex in 1960.

In Great Yarmouth, **Ethel Leach** went on to many firsts for women in the inter-war years — first female Justice of the Peace in 1920, first female Mayor in 1924, first female councillor in 1925, first female alderman in 1929. She died on 10 April 1936 at the age of 86, after 54 years of public service.

7

# 'Woodpeckers', nature lovers & photographers

Many women were striking out in their own ways in early-twentieth century Norfolk, and they included women whose primary concerns were far away from politics. Several made their mark in photography and others in conservation. One who combined both interests was **Emma Louise Turner**. Born in 1866, she was brought up in Kent but her fame comes from her photographs and writings on nature in Norfolk. She worked for twenty years at Hickling Broad, mainly living on her boat the Water Rail or in a hut on an island in the Broad that has now become known as Turner's island. In 1911, her photographs of bitterns there proved that the bird was once more nesting in Britain, after having become extinct here in the later nineteenth century. Her photograph won the Gold medal of the Royal Photographic Society. She wrote articles in Country Life and

*Emma Turner, on Scolt Head island.*

these formed the basis of her book *Broadland Birds* published in 1924. Exquisitely written and illustrated, this established her as leading the way in the female contribution to ornithology.

In 1924, she became the first 'watcher' at the Norfolk and Norwich Naturalists' Society bird reserve, continuing in this post – unpaid –

for two years. Her story is told in another book, *Bird Watching on Scolt Head*, published in 1928.    Emma Turner died in Cambridge on 13 August 1940, aged 74.

**Marietta Pallis** was another conservationist associated with Hickling. She was born in Bombay in 1882, a daughter of the Greek poet Alexandros Pallis. She came to England at the age of twelve, went on to Liverpool University between 1904 and 1907, and then to Newnham College, Cambridge from 1910 to 1912.

She made films of Broadland scenes in the 1920s, which are now with the East Anglian Film Archive in Norwich. Marietta lived at Hickling from 1935, sharing a house at Long Gores Marsh with her partner Phyllis Clark. She created the Eagle Pool in the marsh, with an island in the shape of a double-headed eagle. This involved her digging through the peat. As a result she was able to give useful information to Joyce Lambert, who produced scientific evidence in the 1950s that the Broads were not natural lakes, as had generally been supposed, but made by men digging for peat on enormous scales in the Middle Ages.

Marietta lived at the Great Hospital in Norwich for the last few years of her life, dying there at the age of 81 in 1963. She is buried on her marshland island in Hickling.

Another very significant female photographer was Olive Edis, born **Mary Olive Edis** in London in 1876: her father was a medical doctor. The family took holidays in Sheringham and in 1905, Olive and her sister Katherine opened a photographic studio in Church Street. Katherine left Sheringham on her marriage in 1907, Olive then continuing to work there alone: she also had a studio in London. Her sitters ranged from famous politicians and literary figures to local fishermen. At the end of the First World War she was appointed to photograph female military personnel, thus becoming Britain's first official women war photographer. Cromer Museum has a major collection of her photographs and the Norfolk Record Office has her portrait of Lilly Jackson, who is referred to below.

In 1928, at the age of 52, Olive married Edwin Galsworthy, a solicitor and a cousin of the writer John Galsworthy. They moved to South Street, Sheringham, where she had a new studio built at the back of their house. Edwin died in 1947, aged 86, and was buried in Sheringham cemetery. Olive died in London in 1955, at the age of 79. She was

cremated and her ashes buried with her husband in Sheringham.

Norfolk women played their part in literature and art, as well. **Dorothy Wynne Willson**, yet another pupil at Norwich High School for Girls, burst into fame with her first novel, 'Early Closing', published in 1931. Tragically, she died in the following year aged only twenty-four. **Lilias Rider Haggard**, the daughter of novelist Henry Rider Haggard, became a writer herself: her story has been told in a new autobiography recently published by *Poppyland Publishing*. **Kate Norgate** was one of the most respected historians of a century ago. She was born in London in 1853: the Norgates were a long-established Norfolk family and as an adult she lived in Church Lane, Gorleston. Her first book *England under the Angevin Kings* was published in 1887, and she continued the story with works on King John and King Henry III, later writing a separate book on Richard the Lionheart. She wrote many other articles, including 44 biographies of medieval personalities for the *Dictionary of National Biography*. Kate died in Gorleston on 17 April 1935. Her obituary in the *The Times* called her 'the best known and probably the most learned woman of what may be described in the pre-academic period', placing her in the context of 'a new period of historical writing by women'. In the twenty-first century some of her writing was reworked into short biographies by Amazon for their kindle readers.

**Catherine Maude Nichols** was perhaps the greatest artist among these women, and her story has also been told in a book published by *Poppyland Publishing*. Born in Surrey Street, Norwich, on 4 October 1847, she was the eldest of four children of William and Matilda Mary Nichols. William was surgeon at the Norfolk and Norwich Hospital. In 1846, he married Mary Banister, a rector's daughter. When Catherine was eighteen, her father served for a year as Mayor of Norwich. Catherine was a very talented artist, exhibiting at the Royal Academy, and in galleries throughout the world. She had a studio at 73 Surrey Street in Norwich, and was first President of the Woodpecker Art Club in the city, founded in 1889. When the Royal Society of Painter-Etchers was founded in 1880, she became its one and only Lady Fellow: it was another ten years before a second lady member joined her. *The Times* in 1906 praised her works 'whose success is one of many proofs that in some branches of art women are becoming serious rivals of men'. She

*Sketches by Norwich artist Catherine M. Nichols.*

was a great lover of animals and was President of the Norwich Anti-Vivisection Society.

Lilly Bull, who knew her well, summed up her character: 'It was the peculiarity of her temperament that made Miss Nichols such a charming person to know and kept her to the last surrounded by a host of devotees. She was a woman of restless, questing mind, amazingly rapid in speech, talking of all things but never talking nonsense. She had a range of information that seemed to embrace most things worthy of a human creature's thought and breath, more especially religion, philosophy, and art'. The *Eastern Daily Press* commented: 'Norwich has never quite realised that it had in her an artist of real genius and power.'

The Norfolk Record Office has several of her sketches and thirteen paintings by her are in the Castle Museum, Norwich. She also published several books including her sketches, the most well-known being *Lines of Thought and Thoughts in Lines*, published in 1887. She also wrote a novel, *Second Fiddle, a novel of Old Norwich* (1886) and some poetry.

Catherine, a Roman Catholic, died on 30 January 1923, aged 76: she is buried in Earlham Road cemetery, Norwich.

Another talented woman artist was **(Honor) Camilla Doyle**, born in 1888. She studied at the Royal academy of Art and lived for a time in Paris, but in later life resided at 46, The Close, Norwich. Her best-known painting is a lovely image of a lock on Cassiobury Canal, now in the Norwich Castle Museum. She also published three books of poetry between 1923 and 1937. She died in 1944, bequeathing her paintings and manuscripts to the Castle: the latter included poems describing Norwich in wartime.

The Woodpecker Club had other talented women in its ranks, some of whom have already mentioned in other contexts. Margaret Pillow was a member, as Lilly recalled; 'For a great many years she ran, with much success, a high-class confectionery business in Castle Street [Norwich], known as 'Princes'. Here the Woodpeckers held their annual *conversaziones* and the entire suite of rooms were always placed at the disposal of these parties, and they were always crowded with those interested in the artistic life of Norwich.'

Ethel Leach was a founder member of the Woodpeckers. 'One summer she entertained the members to her delightful place at Gorleston, the party were invited to an al fresco reception in the beautiful grounds of Stradbrooke. In a perfect afternoon the assembled guests thoroughly enjoyed themselves, old friends greeted each other, and many new friends became thoroughly at home with each other under the genial influence of the hospitable hostess. After a refreshing tea and thorough enjoyment of strawberries and cream and other seasonable luxuries, the assemblage broke up into groups, sauntered among the groves, and admired the beds of lovely flowers of the most varied description .... The outing will long be remembered as one of the most successful of the many enjoyed by the noble army of 'Peckers.'.

Others included **Mary Radford Pym** and **Lilly Salisbury Bull**. Mary was born Mary Eliza Fitch, the daughter of Robert Fitch, a director of the Norwich Union Life Insurance company, one-time sheriff of Norwich, and a local antiquarian. He was a chemist by profession. Mary was educated at a small local school, Miss Ives' School in the Crescent, Norwich. As a teenager, she was friends with **Emma Sandys**, sister of Frederick Sandys, the Norwich-born artist. He portrayed Mary in a pastel portrait when she

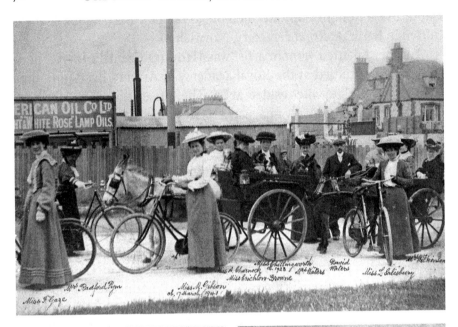

Founded 1887.

NORWICH.

THE WOODPECKER ART CLUB.

President:

Miss C. M. NICHOLS, R.E., S.M.

Vice-Presidents:

The Honourable SYBIL AMHERST.

The Right Honourable AUGUSTINE BIRRELL,
P.C., K.C., L.L.D.

Sir T. DIGBY PIGOTT, C.B., J.P.

WALTER RYE, Esq.

W. NUGENT MONCK, Esq.

H. COOPER PATTIN, Esq., M.A., M.D. (Cantab.)

Committee:

Mrs. G. RADFORD PYM.

Mrs. CYRIL FITT.

Miss BURGESS.

Mr. PERCY BROOKS.

Mr. ARTHUR E. JACKSON (Hon. Sec.)

*Mr & Mrs Farrell*

The President and Committee of
the Woodpecker Art Club have, by
special request, decided to devote an
evening to Social intercourse on Wednesday
Jan. 9th, 1918 7.30 to 9.30 p.m.

Mrs. Pillow has very kindly placed
Princes Tea Rooms at the disposal of
the Committee for this purpose.

Admission will be by Programme
for which application should be made
on or before Jan. 2nd to Miss C.M.
Nicholls, 73, Surrey St., Norwich,
Mrs. Radford Pym, St Marys Croft,
Norwich, or to Mr. A. E. Jackson, 98,
Thorpe Road, Norwich.

A charge of 9d. each will be
made for the Programmes which sum
will be devoted to providing light
War Time Refreshments.

*The Woodpecker Club of Norwich. In the upper photograph, they are on an outing to Cromer.*

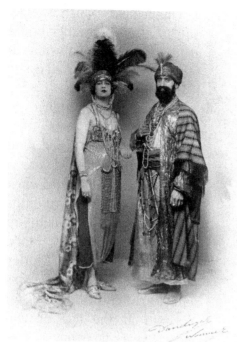

*Margaret Pillow of the Woodpecker Club in theatrical costume.*

was about eighteen years old. Emma Sandys was an artist in her own right, exhibiting at the Royal Academy. She specialised in portraits, such as 'Lady in Yellow Dress' now at Norwich Castle Museum. As a teenager, Mary was once tasked by Emma with finding some hemlock plants — 'it is positively necessary for a picture my brother is doing'. Emma Sandys died in 1877, aged just 34.

In 1882, Mary married George Radford Pym, from Belper, Derbyshire, a solicitor: the marriage took place at St Peter Mancroft church in Norwich. However, the marriage lasted only a few months: Pym left Norwich and the couple lived entirely separate lives from then on (he died in 1914).

Robert Fitch died in 1895, his estate passing to his son John, who himself died without issue in 1904. The estate then passed to Mary, who almost at once gave a large part of it to the city as a public park, known as *The Woodlands*. Mary was a woman who played many important roles in city life, some of which would have been unthinkable for a woman just a generation earlier. She was Vice-President of the Woodpecker Art Club, a governor of the Norfolk and Norwich Library, and a governor of St Peter Mancroft School. Wealthy and extremely generous, her gifts to the public included Sheringham Town Clock, still a prominent feature in the main street: she had a cottage in Sheringham to which the Woodpecker Club members were frequently invited. After recovering from pneumonia in 1913, she gave a house in Sheringham for the use of the local nurse there. Not for nothing was her hobby listed as 'Philanthropic work' in the 1912 *Who's Who in Norfolk*. After she had inherited money from her father, she moved (in about 1903) from

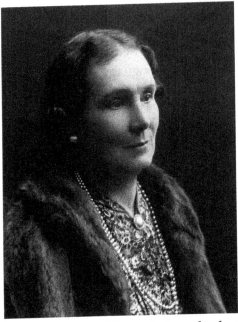

*Lilly Jackson, née Bull in a photograph taken by Olive Edis in her Sheringham studio.*

4, Chapelfield, which she let out, to a much grander house at 10, Chapelfield, known as St Mary's Croft. Mary died on 22 February 1927.

Lilly Bull was born in Cambridge on 9 June 1877, the daughter of Alfred and Catherine Bull: Alfred was a grocer. Lilly's mother died when she was just fifteen months old and she was brought up by her grandmother, Mary, whose husband, Robert Morley worked at Colman's. She was sent to Anguish's School in Norwich at the age of ten, and six years later left to take up her first job in 1884, as companion to Mary Radford Pym in Chapelfield: she was to remain with her until Mary's death thirty-three years later, in February 1927. Mary bequeathed property in Chapelfield to Lilly, and also left her St Luke's Cottage in Sheringham, where they had frequently stayed in the summer months. Three years later, in 1930, Lilly married Arthur Jackson, a Norwich accountant and fellow-member of the Woodpecker Club. Lilly was thus part of the Norwich artistic scene, and did write some poetry and plays including doggerel advertisements for local firms such as Rumsey Wells, the hat-maker. Other, more serious, poems were favourably reviewed in *The Bookman*.

Her chief importance rests in her unpublished memoirs, which are held at the Norfolk Record Office and bring to life the artistic scene in the early twentieth century. The couple lived in Norwich until their house was bombed in air raids in 1942, then moving into their Sheringham cottage. Lilly suffered severe depression in later years, spending some time in Hellesdon Hospital. In May 1952, her body was found washed up on Sheringham beach: the verdict was that she had deliberately taken her own life by drowning. Lilly was 74 years old.

More popular culture can be represented by **Antoinette Hannent**, born Carrera: known from her style of dress and hair colour as 'Black Anna' she entertained at the *Jolly Butchers* public house in Ber Street in Norwich for forty years from 1935, and is still fondly remembered in the city.

Many of the women whose stories are told in this book had been pupils at the Norwich High School for girls, which played a major role in advancing the careers of women in the city. The Girls' Public Day School Company had been founded in 1872 to provide quality education for girls. It opened its first schools in London in the same year, expanding to provincial cities like Norwich in 1875. The women in this book were mainly at the school under the inspirational headships of **Elizabeth 'Lizzie' Gadesden** (1884-1907) and **Gertrude Mary Wise** (1907-1928). Lizzie Gadesden was the daughter of John Gadsden (as he spelled the name), a professor of music in London, and his wife Esther. She became a teacher at Croydon High School and was briefly a headmistress in Newton Abbot, before becoming headmistress at Norwich in 1884, in which post she served for twenty-three years. Her sister **Florence Gadesden** was headmistress at Blackheath School for an even longer period, from 1886 to 1919. On Lizzie's retirement, she moved to Gresham in north Norfolk, dying there in 1917. Florence retired in 1919 and followed her sister to Gresham, where she played a very active part in village life, serving as president of the Women's Institute, founding a men's bowling club and interesting herself in local housing. She died in a Cromer nursing home in 1934.

**Gertrude Mary Wise** studied at Newnham College, Cambridge and was a teacher at Norwich under Miss Gadesden from 1891. In 1900 she became headmistress at Shrewsbury High School. On Miss Gadesden's retirement in 1907, she returned to Norwich as headmistress, remaining in post for twenty-one years. She was also involved in Norwich life, serving as Justice of the Peace and as chairman of council of the Norfolk and Norwich branch of the National Council (or Union) of Women Workers. She retired in 1928, dying in 1934.

# 8

# The Haldinstein sisters

Two marriages in Norwich synagogue led directly to the horrors of the Nazi extermination camps: both involved daughters of Norwich shoe manufacturer Alfred Haldinstein. Alfred was the son of Philip Haldinstein, born in Prussia in 1817. He moved to Norwich, where he married Rachel Soman. Rachel was born in Yarmouth in 1827 and was the daughter of another immigrant, David Soman, who had moved to Norwich and set up a successful shoe making business. Philip inherited this, and expanded it into a major employer in the city.

Philip had several children, and on his death in 1891, his eldest son Woolfe succeeded him as head of the firm. Woolfe died just five years later and was succeeded by a younger brother, Alfred, born in Norwich in 1850. The firm prospered, with a huge factory in Norwich (part survives at the top of Queen Street), a branch in London and other factories elsewhere: there were more than 2,000 people on the firm's pay roll in the early twentieth century. Alfred was an important figure in late Victorian Norwich, serving as city sheriff.

Alfred married twice. His first wife was Emma Samuel, daughter of a Norwich watchmaker, and one of the oldest-established Jewish families in the city. Their children included **Constance Emma Haldinstein**, born in 1879. Alfred was widowed in 1885 when Emma died, aged only thirty-five. In 1891, the family were living at 43 Unthank Road, where they had a live-in French governess (actually born in Germany): no doubt Connie, eleven at the time, was largely in her charge. Some years later Alfred married a second time, his new bride being Edith Rebecca Emanuel. The couple had several children, including **Joyce Yolande Haldinstein**, born in 1900.

Constance and Joyce, half-sisters, were over twenty years apart in age. By 1900 the family had moved to a new and very large house, Thorpe Lodge (now the Broadland District Council offices): this is where Joyce was

*Thorpe Lodge, where the Haldinstein family lived.*

born and brought up. The family was a very wealthy one with six live-in servants. Constance and Joyce went to Norwich Girls' High School, then in the Assembly Rooms in Norwich, and, on at least one occasion, the school sports day was held in the grounds of Thorpe Lodge. Constance was at the school between 1889 and 1893, Joyce from May 1912 until Christmas 1917.

On 20 June 1908, at the age of twenty-eight, Constance married Saloman Elias at the Jewish synagogue in King Street, Norwich. He was from Rotterdam in the Netherlands, a doctor by profession and the son of Moses Elias, a merchant: Saloman was thirty-seven at the time of the marriage (he was born at Strijp on 14 May 1870). The family returned to Rotterdam. Their first child, Alfred Joseph Henry Elias was born there on 26 September 1909, and they later had other children including a daughter, Charlotte.

Joyce went on from Norwich Girls' High School to Saint Felix School in Southwold, Suffolk, and in 1919 went on to the Swanley Horticultural College, Kent. Because of their age difference, seventeen years — and a World War — passed before Joyce followed her sister, also marrying a Dutchman at Norwich synagogue, on 18 June 1925. He was Johan Rozendaal: at twenty-seven he was three years her senior and a manufacturer living in Enschede, a Dutch town very close to the border with Germany. They had no children. They made frequent trips

CERTIFIED COPY OF AN    ENTRY OF MARRIAGE    RTA 2
Pursuant to the    Marriage Act 1949    M. Cert.
S.R./R.B.D.&

CAUTION: There are offences relating to falsifying or altering a certificate and using or possessing a false certificate. ©Crown copyright.

WARNING: A CERTIFIC
NOT EVIDENCE OF ID

**Registration District** Norwich

1925 Marriage solemnized at The Synagogue **in the District of** Norwich **in the** County of Norfolk

| Columns:- 1 | 2 | 3 | 4 | 5 | 6 | 7 | 8 |
|---|---|---|---|---|---|---|---|
| No. When married | Name and surname | Age | Condition | Rank or profession | Residence at the time of marriage | Father's name and surname | Rank or profession of father |
| 10 Eighteenth June 1925 | Johan Rozendaal | 27 years | Bachelor | Manufacturer | 31 Parkweg ENSCHEDE HOLLAND | Harry Rozendaal | Manufacturer |
| | Joyce Yolande Haldinstein | 24 years | Spinster | | Thorpe Lodge Norwich | Alfred Isaac Haldenstein (deceased) | Boot Manufacturer |

Married in the Synagogue according to the Usages of the Jews    by Licence    by me.

Vivian G Simmons

This marriage was solemnized between us, { Johan Rozendaal / Joyce Yolande Haldinstein } in the presence of us, { Elizabeth Emanuel / A H Caro } { M Fabritz / D Benjamin Secretary for marriages }

Certified to be a true copy of an entry in a register in my custody, P. Rachel Farmer. Deputy Registrar/Superintend

Date 14 Ja

*Marriage certificate, Joyce Haldinstein and Johan Rozendaal.*

to England, spending each Christmas in Surrey with her sister Mary who had married Alfred Caro: one of their children was Anthony Caro, the well-known sculptor.

By 1940, the Elias family had been in the Netherlands for over thirty years, and the Rozendaals for fifteen years. Then, suddenly and brutally, their lives changed for ever.

On 10 May 1940, the Germans invaded the Netherlands; after just six days' fighting, the country was forced to surrender and came under Nazi rule. Artur Seyss-Inquart became Reich Commissioner and began to persecute the Jewish population of the country. Deportations from the Netherlands began in the summer of 1942, many initially to Westerbork, a transport camp in the north of the country, others directly to the camps at Auschwitz or Sobibor. About 107,000 Jews were deported from Holland between summer 1942 and September 1944: just 5,200 survived the war.

Saloman and Constance Elias and their son Alfred were among the victims. They are mentioned just twice in letters home by Joyce, the latest in September 1941, when they are said to be both quite well

and together. This was not to last: in 1943, Saloman and Constance were taken by train to Sobibor. This was not a work camp but a death camp — the couple were gassed there in the summer of 1943. Alfred died in Auschwitz the following year. The couple's daughter Charlotte survived: she had married Max Polak and moved to the United States before the war.

Joyce Rozendaal had a very different story. We know about it because the letters she wrote to her family during the war have been preserved at the Wiener Library in London, and they tell, very movingly, of what life was like for a Jewish women in Nazi-occupied Holland — and also the fantastic story of what eventually happened to change her life. She also put together a memoir of experiences, also at the Wiener Library. Near the beginning of this she writes: 'Sixteen years previously, as a Norfolk girl, I had become engaged to a Dutchman, and, after my marriage, went to live in Holland.

The first surviving letter was written to family members on 2/3 May 1940, before the German invasion. Joyce wrote to tell them that her mother had died in a nursing home in Bournemouth, [she died on 27 April 1940]. Joyce was with her when she died, as was Joyce's sister Mary, but Joyce returned to Holland before the cremation at Golders Green. She went back by plane, unusual at this date, and found her husband Johan laid low with tonsillitis and 'so glad to have wifey' as she recorded in another family letter. In her absence Johan had told Connie about Edith's death and Joyce was planning to go and see Connie and 'Sally', as Saloman was known in the family. She was thinking of passing Edith's two best dresses on to Connie (Edith was, of course, Connie's stepmother). However, people were already fearing a German invasion and its consequences: 'Nearly all the Jewish families have left Enschede for good and I hear many in Holland have emigrated ... life appears normal tho' most uncertain'. Johan was cycling to and from work four times a day.

The Germans invaded the Netherlands just seven days after Joyce wrote this letter: within a week they had defeated the Dutch and were rulers of the whole country. The Rozandaals, like many thousands of Jewish families, drove to the Dutch coast in the hope of finding a fishing boat to take them out of the country: it was too late. They returned, stayed the night with Connie and Sallie and then went back to Enschede

to await whatever fate had in store.

Conditions for Jews got worse and worse as continual restrictions were placed upon them.

21 Mar 41: Joyce wrote: 'Have been forced to move from their house in the country to town where John works' (Her husband, whom she previously referred to as Johan is always called John from this point.)

At first they were told they could stay if they took in extra lodgers, but on Monday 3 March the house was commandeered to be used as a military

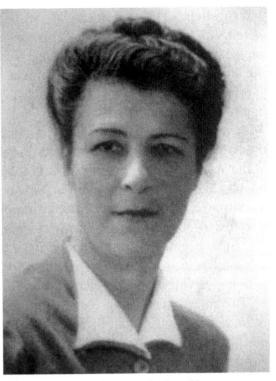

*Joyce Yolande Rozendaal-Haldinstein.*

hospital. They were told to leave by Wednesday: they had to find themselves somewhere else to live by then. They were fortunate enough to find an empty house: its owner had died just two days earlier.

15 June 41: 'Pin pricks and jabs follow incessantly. A seaside holiday for instance is out of the question.' They were hoping to celebrate their 16th wedding anniversary at a hotel in the woods they had been to before - 'so far we are still welcome there but mostly not!!'

In September 1941, there was a round-up of Jews in the Netherlands, just one of very many. Johan was one of those the Nazis came for, but by a lucky chance he was away, staying with his uncle. He managed to cycle away, and from then was a wanted man, staying wherever he could, at first in an isolated farm, later in a fisherman's cottage, and he was eventually 'admitted' as a patient in a mental asylum. As Joyce wryly noted 'his was not the only faked case.' Joyce was on her own: she managed to see Johan twice, but her house was watched and she was often followed, so this was very risky for both of them.

24 June 41 to Merrie and Daphne in Switzerland: 'John is all right I know though of course we miss each other terribly. We write each other (which is heavenly) but consider it unwise to meet as that might means Davy Jones locker afterwards. See?' [Joyce often uses the words 'See' or 'Twig' when she is putting something circumspectly, to get information over to her reader under the nose of the censor, and she — rightly — thought that every letter was liable to be censored]. 'The latest is that I have to be indoors in my own house by 8 each eve, but my dear golf friends all drop in after that to cheer my loneliness, but of course none of the family come or kosher friends. This is only local and may change later, but what does that matter compared to other things? Lectures, concerts cinemas and theatres and even the library and swimming baths are taboo, which raises our shoulders and not our hair!' To avoid recriminations, she now often signs her letters with a false name: she signs this letter 'JOE BUSTER'.

A later letter reveals her loneliness and despair:

20 Sep 41: 'Connie is quite well and with Sallie', but Joyce herself writes that she is 'in despair with loneliness and uncertainty, and can hardly write from blurred eyes: 'I am so lonely and sad and for many it is still more critical .... All hotels or boarding houses etc are taboo for us - see? But I live for my odd days away - like lights at the end of a tunnel - Twig?' JOE BUSTER

In the same letter, she manages to convey to her relatives what is going on by presenting it as a novel she has write recently, 'Terror Afoot' by 'Won Hugh Noes'. It is the story of two lovers who staying in a strange village when they and others are suddenly attacked; , 'no mercy, no excuse, over 100 victims are bundled off, perhaps never to return, some on foot, some in cars, shut up for two days in the local school, where contact is impossible, before transportation to the mines. Meanwhile the male half of the couple has managed to escape by bicycle and find refuge in a little cottage; the two lovers are separated but mange to meet occasionally. She concludes; 'This is the end of the first part of the book. I've not read any further yet you can just imagine how it has worked me up can't you?'

The next letter is dated 3 Nov 41, and addressed to 'Elizabeth and Edith', (perhaps falsified names). Joyce writes that she has been a grass widow since middle of Sept: 'John is having a quiet holiday right away

and he is alright there I think. I go to see him occasionally which is heavenly and it is better for his health to be away from this treacherous winter climate, when you can catch the 'grip' and flu at any moment. See?' She does not go to the Market any more, 'nor to any concerts, theatres, lectures, nor hotels, nor restaurants, nor to the movies or the Lending Library - also I don't go into the parks anymore nor have meals out anywhere except at friends nor stay anywhere but at relatives or friends - see? But these are all secondary pinpricks compared with the loss of our partner and our butcher and our doctor and dentist who joined my mother with about fifty others of our people.'

'Joined my mother' would have a significance to the readers that the censor would not pick up. As we saw in the first letter, Joyce's mother is dead.

Later in the same letter she gives a moving description of her own life but as though she was describing another person: 'I met that horrible woman Yolande Joyce the other day. Apparently being a Jewess she may not keep any Christian servants at all, male or female - which of course serves her jolly well right I know you'll agree. Well her boy is away for an indefinite time - I suppose the end of the war and she has a good sized house in the town now - since she left their country place in March. She told me she was looking for a nice childless Christian couple but so far she's not been successful though there were several nibbles. See ... I asked the female what she was going to do since she may not stay in any place longer than a month where there are Christian maids. She thought of keeping a bed R[oom] and sitting R[oom] and board with the new tenants when or if she stays in the town. But I found her v restless and I expect she will slip off on the quiet and join the boy somewhere, and I can't blame her really can you? She seemed frightfully worried and busy clearing out cupboards and desks and making room for whoever comes apparently and all her precious bottled produce and so on she thought better elsewhere. She luckily has a good advisor as it seems a mighty job to tackle alone. I shouldn't care to have strangers use my furniture — would you? But I suppose she needs the rent back badly these days and both the maids and her old gardener must be gone by the New Year. Apparently the chauffeur who used to drive for the firm is in their pay so he'll go and work in their factory. You remember the woman I expect — tho' she's quite skinny

now with grey hair but she still seems full of go and cheery! Quite remarkable considering all they are going thro' — every week some new restriction — which of course is quite deserved — I know you'll agree.' Joyce signs this letter 'fond cousin Hall'.

The letters include two both written on 11 Nov 1941. Mary wrote to Nannette: 'what John is suffering, where he is, where he is going to, and if he will be alright - none of these things will bear thinking of.' On the same day she wrote a draft letter to Joyce: 'All our thoughts and prayers are for you. I have just seen your letters to Nannette and Merrie and we are heartbroken for you. I do hope that by now you are better. We are longing to hear more news and better news. How we wish we could do something to help you and to cheer you. All our sympathy and love is with you darling. We admire your courage so much and we know all will be well in the end.' She sent the latter to Nannette asking if she thought it might do Joyce harm if it was sent: as it is still in the family archive, she probably decided against sending it.

On 1 February 1942, Mary wrote to Nannette sending on a letter from Joyce 'it is a brave sad letter and all feel heartbroken for them and so miserable that we are unable to help them.' Joyce is planning to let out her house and join John so that whatever trials they have to go though they will be together.

In April 1942, John managed to escape through Belgium and France to Switzerland. He was able to send a postcard from Switzerland, with 'birthday greeting': this was a pre-arranged code: at least he was safe! It was a journey it would be impossible for Joyce to copy as it involved travelling disguised as a priest for a great part of the way. Fortunately there were other groups of people prepared to risk their lives by smuggling Jews out of Holland.

By June 1942, Joyce could not bear to live in Holland any longer, and decided to try an escape herself: 'It got impossible at home — I could go nowhere — nor travel etc — and I suddenly saw a chance of trying my luck — so without hesitating I took the risk.' She was helped along the way by friends — 'for fear of spoiling it for others I cannot go into details'.

In fact she was the first woman to undertake a hazardous journey along a route planned by friends and well-wishers.

## JOYCE MAKES A BREAK

Joyce had thought of escaping before, saving what provisions she could and keeping them in an outhouse: she lost them all when someone broke into the shed. Finally it was time to go. She put on two of everything, put a few old clothes into an old case, sewed 100-guilder banknotes into her leather belt and took all she could find to drink and eat: some synthetic lemonade and bread 'made from bean flour and rubbish'. She and two friends cycled westward together for about twenty miles: at one point they were pulled up by an official who told them off for cycling three abreast! When they were in the middle of nowhere, she dismounted, got onto a very old bicycle that one of her friends had and cycled on alone, eventually meeting another cycling couple who took her to their house — which happened to be on the Dutch/Belgian border. They gave her a 'greasy-looking, dog-eared Belgian identity card' and she sneaked across the border while the guards were looking the other way.

She was now in occupied Belgium, all on her own. After a long wait, a man came up and asked for a pre-arranged sum of money, which she gave him. He then asked her to go back to Holland as he had been intending to take her with two other women, who had not turned up: to persuade him to take her, she gave him their 'fares' as well as her own! The man took her to his house, where she met his wife, known only as Madame. The family had one house in Belgium, and another on the Franco-Swiss border and the plan was for the two women to travel there, in easy stages and on local transport, so that they appeared at all times to be locals, not long-distance travellers. They would not even travel in the same compartment, as two women together from the same Belgian town might arouse suspicion. Madame assured Joyce that she had done this many times before, although never before, she admitted with a female refugee!

Joyce stayed the night and the next morning the two women got on the local tram to Antwerp. Joyce was stopped by an official who searched her case: he was not looking for an escapee but searching for potatoes, a very valuable commodity at a time of starvation and one it was illegal to transport. He let Joyce continue her journey and the two women got off the tram at the railway station where they boarded a

train to Brussels. From there, they caught a train to Namur, and on to Nancy: they had made it into France. They crossed the border in the company of a group of women heading for the local casino!

During the journey, she was asked many times for her ID card, and it always passed muster: she wrote later 'I fondled the dirty yellow surface as a lover may treasure the portrait of his sweetheart'.

The two women spent the night in the waiting room on Nancy station where they were joined by a male Belgian Jew who was to make the journey with them. At 5.30 am, Madame led them to a nearby siding where an empty train was waiting and they got on board and stretched out for a couple of hours. It then moved into the station to become the early morning train to Belfort: Madame must have known all these local details intimately! At Belfort, the three got out and had lunch at a cafe, Madam being clearly known by its proprietor. They then got another train to Montbeliard, where Madame's second house was. They met two of her children, Bertha and Jacques, and stayed the night. On the following morning, Joyce, the Belgian, Bertha and Jacques boarded a local bus, standing all the way, to the remote village of St Hippolite thirty miles away. They had intended to catch the post bus onwards, but it turned out to be carrying German soldiers, so instead the four of them walked up steep hills to a poor, isolated farmhouse, run by a Frenchman, his wife and six sons. Bertha took back the Belgian ID card and she and Jacques set off down the hill. The two refugees settled down as best they could to get some sleep.

At 3 am, two of the sons led the refugees out of the farm into the mountains beyond. First they had to cross a torrent on a bridge of rough planks in pitch darkness. Then they started their climb, Joyce finding that 'my comfortable rubber-soled shoes, that had been a joy up to now, cause me to slip back at every step on the loamy soil'.

She wrote later to her family:

'Can you imagine what it is like getting a little peasant boy to carry your canvas golf bag while you carry hand bag and sling your big coat through your note-filled lined belt — and then at 3 in the morning —pitch dark in a thunder storm start climbing on the Alps with another peasant boy doing the same for a poor little sick man of 50 who has never seen a mountain before.

One hand I held the boy, as I see so badly in the dark, and after the man collapsed I slung his extra luggage over my shoulder and dragged him up too. It was terribly slippery and steep and one kept falling back and perspiration ran off me and everything was soaked thro'! Hurry, hurry — the light is breaking — the boys must get back and the guards will be seeing us.' This part of the journey lasts another hour until they reach a stony field where the ground is less steep. Then 'we start ascending a very steep slope leafy and soft and fairly easy except for trees everywhere. The boys are marvellous they know each step in the dark. Night is breaking — we ascend once more — I begin to feel my fatigue but will not give in ... Suddenly we reach the boundary stone! We're there!'

They had made it to Switzerland. The boys silently disappeared back down the mountain and Joyce and the Belgian walked through the wood and promptly got lost, almost winding up back in France. Eventually they found their way onto a road. Soon they were stopped by a gendarme, who marched them to a nearby Customs Post: she could clearly see the German guards just the other side of the barrier. Here she was told: 'Rules are Rules and no papers mean no entry - so back I must go the way I came! Just imagine my feelings! Can you?'

Gradually the officials listened more to what she had to say, and she told them her husband was already in Switzerland (she did not want to trust them with this information at first). They got in touch by telephone with Johan. He confirmed her story and she was allowed to stay (but the poor sick man who came up the mountain with her was sent back). Joyce had to go to prison for a few days while the formalities were completed, but she was just happy that she was 'breathing the wonderful Swiss air at last' — and that at last, after all she had been through, she was safe. Joyce was soon reunited with John, who travelled from Berne to Nyon to meet her. She surprised him at the hotel in Nyon where he was staying: 'Kiss John on top of his bronzed head having lunch under the trees by the lake at his modest little hotel'.

Joyce knew very little of her family in Holland as she purposely lost all contact with them, as she was sure she was being watched: 'They did not get me but they would have I think if I had not got away when I

did.' It turned out that she had made her escape just in time as within two months Switzerland closed its borders: on September 5<sup>th</sup> 1942, she wrote: It is a good thing we waited no longer as it would not have been possible now!'

Between 1938 and 1942 more than 28,000 Jewish refugees had been allowed into Switzerland. After September 1942, refugees arriving at the border were sent back: more than 9,000 were refused entry

The couple lived in Switzerland for over two years. A letter written on 31 December 1944 shows that by then she had learned that Saloman and Connie were dead.

Eventually the war ended, and, slowly, refugees like Joyce and John were able to go back to their homes. John probably went first, as Joyce came to England in June 1945, spending time with Mary. They were back in Enschede by January 1946: in her memoir she wrote, 'We were so glad to be back it seemed too wonderful to be true and we asked ourselves if the last five years had really happened. However, life still had its problems: they were desperately short of food. Even vegetables were rationed, and she wrote to her relatives that they could only get carrots and onions. She asked Nanette to send food parcels, and even hoped that she could send a hoover - 'the place is so dirty'  - and an electric kettle. But at least they had survived and were free.

In fact, Joyce did not survive the war by many years. She died on 26 January 1949 at her house in Enschede: she was 48 years old. Johan survived her: he described her in the death notices as 'dearly beloved by all who knew her'. She was cremated at Westerveld near Haarlem.

# 9

# Elsie Marechal, née Bell

**Elsie Marechal**, before her marriage **Elsie Mary Bell**, was born in Acton, Middlesex on 21 June 1894, the daughter of Robert and Alice Bell: Robert ran a general store. Because of her poor health she was brought up by relatives in Great Yarmouth. At the time of the 1901 census, she was living at Priory Plain with her aunt Anne Gowen, and Anne's parents, Henry, a retired carpenter, and Mary. Ten years later, Elsie and the family (apart from Mary, who had died in 1909) were at 210, Palgrave Road. Anne Gowen was a schoolteacher at the Priory School in Yarmouth which Elsie attended. In September 1913, she went on to the Teachers' Training College in Norwich, then in College Road. She moved to London in 1915 to take up a teaching job. In the

*Norwich Teachers' Training College.*

same year she met Georges Marechal, a Belgian soldier then at a London hospital. The couple married in 1920, and moved to Koblenz. They had children there — Lilian, born in 1922 who died in 1925; Elsie, born in 1924; a stillborn child; and Robert, born in 1926. Elsie returned to England with her children several times.

The family moved to Brussels in 1929. They were there when Belgium was invaded by the Germans on 10 May 1940. The country was soon occupied, and the Marechals became actively involved in helping Allied

*Elsie Marechal's drawing of her daughter (also Elsie) in St Gilles prison, Brussels.*

soldiers to escape from the Germans. The men would arrive at Elsie's house and be fed (Georges was out at work in the day), while Elsie junior gave each man a packet containing soap, a comb — and a false passport. Clearly, they were risking death by these actions. They were caught when Gestapo informers infiltrated the escape route, and were taken to St Gilles convict prison, where they were interrogated and tortured: this was the prison where Edith Cavell had been imprisoned and then executed in the First World War. After four months, they were tried. Bobbie, still a schoolboy, was set free but the other three were sentenced to death. Georges was shot in October 1943, and the two Elsies spent the rest of the war, first in St Gilles prison in Brussels, then in German prisons and concentration camps, enduring many months of sheer hell. Elsie survived and wrote an account of her experiences which she sent back to the Teachers' Training College. It is now held by the Norfolk Record Office, one of the most moving and tragic of the many thousands of stories held there. These are the kinds of experiences that she relates:

## RAVENSBRUCK:

A drizzling rain added to the gloomy aspect of our arrival in the camp and a shudder went thro' us as the barrier shut behind us. We were directed to a huge tent erected in the centre of the camp. As a rule the new arrivals passed the first night or so in this tent, but many spent weeks there too. There were about 1600 Hungarian Jewesses in the tent — lying or sitting in filth on the ground. They had been taken by the Germans before the advancing Russians near Budapest, to dig defence trenches, and finally arrived here by forced marches with little or nothing to eat: those who could not follow were simply shot down. One or two mugs of hot soup improved our morale a little for we were starving. The awful spectacle of this tent is engraved on our minds forever. Some were ill or dying — others sleeping on blankets in pools of water, others talking, eating or groaning. A row of utensils of various shapes, pails, jugs, cans etc at the back of the tent took the place of lavatories. Imagine the state of these towards the morning, overflowing, and the smell thereof. We spent the best part of the night walking up and down trying to keep warm, but in the end were forced to lie on the damp ground and sleep an hour or so.

The next afternoon we were all lined up outside the 'baths'. There were hundreds of Jews to pass before us. As they entered they were obliged to leave all their baggage in a tremendous heap outside the building. It was raining and bags, sacks of clothing and food were thrown pell-mell in the mud. We waited in the beating rain and it was midnight before our turn came. We were stripped of everything except corsets and shoes — our bags were thrown open and all our things chucked out and trampled on. We were just allowed to keep spectacles, combs and toothbrushes. After the bath we were given a thin chemise, knickers, dress and coat — old clothes of those who had passed before us. The result was often ludicrous and when one of our companions (a countess) donned the gypsies outfit allotted to her, we were forced to laughter. E and I found ourselves the possessors of short Russian jackets, rather cold for the legs, but

ELSIE MARECHAL, NÉE BELL

being padded protected the chest fairly well.

The extraordinary thing of the camps was the comparatively few Germans used to run them. The policing was almost entirely done by Poles and I must say they did it very effectively. They had suffered themselves and seemed to wreak their vengeance on us. What shouts and threats would not do, the 'schlag' would do. How many times have we not seen their victims fall on the ground under their blows?

We were sent to our 'block'. There were 32 blocks in the camp and the chiefs of the blocks were often Poles. The dormitories were filled with wooden constructions of three-storied beds separated only by very narrow gangways, and we were put two or three in a bed. The refectory was originally used for meals, but with the over-population there were beds there too. The soup was served there, but only a minority could be seated at the tables, so it was the general rule to eat in our beds.

At 5 am we were up and turned out of our blocks for the 'Appel' or roll-call. We had to arrange ourselves in the appointed spaces in rows of ten and wait for the 'Offizierin' to pass and control the numbers. If there was too many or too few in the total of over 50,000 women the whole camp had to stand waiting until the error was discovered. Every day in rain, snow or wind we stood under the stars and under the glare of electric lamps until the dawn broke.

After the number 'Appel' there was the work or 'Arbeits Appel'. We had to arrange ourselves on the 'lager Strasse' and then there was the march past. All those who had no fixed work, the 'Verfischbar' [correctly Vefuckbar — Available] were liable to be pounced upon and sent to work on various duties such as digging trenches, pushing carts of goods, or refuse, or corpses, carrying heavy loads of potatoes, coal, chopping wood, loading and loading railway trucks. Just outside the camp trucks arrived bringing goods of all descriptions — furniture, clothes, porcelain, silver, mattresses, linen, utensils of all sorts — all goods plundered from Poland etc. We were obliged to unload these, sort them out and pack them in large halls. There were here good opportunity to take possession of woollen garments,

knives, spoons and other little luxuries, but of course it required
a little ingenuity in passing them for we were searched and
sometimes stripped naked for the search. What astonished us
was the awful waste, for fine linen and articles of value were left
rotting together with rags in huge piles in the open air; when we
moved them under the snow they were hot and steaming with
fermentation.

Those who had any qualification as doctor or nurse were
employed in the infirmary. A great number of prisoners were
employed by Siemens in munition factories attached to the
camp and received better treatment.

After the 'Appel' it was a great rush of all those not taken for
work to enter the block and creep in to bed to try and get warm
— the bread ration for the day was generally distributed about
II am. Then at midday came the soup — nearly always of swede
turnip, sometimes cabbage. Our first gesture on receiving the
soup was to turn in it to see if there were any pieces of meat, but
these were very rare for the soup had passed thro' other hands
before reaching us. There was a tremendous leakage with the
food — whole kettles of soup were stolen from one block by
another.

If one prisoner disobeyed the rules, the whole block was
punished by a pose of four or five hours or more out in the cold.
Our greatest sufferings were from hunger and cold and still
those who had been there a long time told us that conditions
were greatly improved — that formerly dogs were trained to
jump at those wearing the convict uniform — that there were
three 'Appels' a day and that punishments were much more
terrible. Now there were not enough striped convict dresses to
go round, so all other coats and dresses had to be marked with a
big white cross on the back.

The most redoubted {sic} illness was dysentery. It was a
general rule that new arrivals caught this almost immediately
and one saw them change in a few days. Medicine was very
scarce, and it required 40 degrees of fever to be admitted to
the infirmary. The bodies of those who died in the night were
stripped and put on the floor of the wash-room until the next

day when they were collected by the cart to be taken to the crematorium.  No film, nor book, nor description can give the real atmosphere of Ravensbruck — the awful smells of dysentery, of the crematorium are missing — the acute sensations of cold and hunger and the glimpses of suffering and dying faces — the handling of naked dead bodies like refuse — the commerce for bread and clothes — all this cannot be pictured — it must be lived to be realised.

At the beginning of February the old, the thin and ill were sorted out.  We passed in a long queue stark naked one after the other before the doctor who put the medical cards on one side of all those picked out as unfit.  All these were sent to a camp, a 'Jugend Lager' as they called it, a few miles from Ravensbruck to be specially looked after.  This special treatment turned out to be starvation — no blankets and long poses in the cold. Several died and after a short time all those who remained were sent on transport — the black transport — none of those in that transport have been heard of since.  Everything leads us to believe that they were exterminated in the gas chambers. I had been chosen to go to this 'Jugend Lager' but thanks to a doctoress whom I'd known in the prison of S Gilles who changed my medical card I was able to escape it and remain with E.

The Russian advance to the Oder brought about rumours that Ravensbruck was to be evacuated.  A bombardment on the electrical installations put the camp several days without light, and there were often no more roll-calls in the morning - a thing never heard of before.  Those working in the forest outside the camp heard the cannon booming in the distance.

There was a certain number of Polish women in our block known to us as the 'lapins' (rabbits).  These had served as experiments to the German doctors.  Some had had bones removed, others operations on certain nerves or muscles — there were many women and even Jewish children who had been sterilised.  E had a Polish friend and one day she was upset, for one of her friends had been condemned to death and executed by being hung up by the feet in the chimney of the crematorium.

## THE MOVE FROM RAVENSBRUCK TO MAUTHAUSEN:

The evacuation of the camp began at the end of February.
We dared not go out in the streets of the camp for groups of
women were often pounced upon by the offizierin to be sent
immediately on transport, and these were often the 'black
transports'. The blocks were often emptied one after the other —
the big tent in the centre of the camp was broken down — there
were one or two skeletons found under the beds. The food
became rarer, the soup sometimes arriving only at night. One
day, the 1$^{st}$ of March, everybody was ordered out, so in a few
minutes we were outside with all our worldly possessions in a
linen bag. We left Ravensbruck, a long column of 5,000 women
marching five abreast. We each received a loaf of bread and a
small packet of margarine and sausage as food for the journey
which was reckoned to last four or five days. We waited for two
hours until we were cold to the bone before the train arrived.
Then we were pushed into cattle trucks — 70 or more women
to a truck. Then followed the most painful journey of all. It
started snowing and freezing once more. We journeyed south,
crossing Czechoslovakia to Mauthausen in Austria, one of the
worst reputed camps for men. In each truck was an SS and an
offizierin who had the luxury of straw to sleep on; there were
also two tin pails for lavatory use. The first day we were able to
get water to drink, but the following days we had only snow to
quench our thirst. As for washing, that was out of the question.
The truck E and I were in had been used for transporting coal,
so after four days and nights in that truck the result can be
imagined. We had no covers and no exercise. All day long the
truck was open and the cold was bitter. E's feet became frozen
and she suffered badly from this. At last after nearly five days we
arrived at Mauthausen on the Danube, not far from Linz. It was
night and the village was quite picturesque under the snow, but
the camp was built on a height and it was a five mile walk. The
column, always five abreast, started the climb, but after such a
journey many women could hardly walk — those who fell behind

were put on the side of the road and a few seconds later a rifle-shot told us that their sufferings were ended for ever. E advanced with great difficulty on her frozen feet and I passed the most anxious moments trying to help her along. It was marvellous what an encouragement to advance those rifle-shots were, however, and at last we reached the top and entered the camp.

## RELEASE AT LAST:

We spent the night in a 'blok' and the next morning we were marched, always five abreast, out of the camp and were left waiting on a flat stretch of ground on the side of a hill. Where were we going? And how? Could it be true that we were going to a Red X camp? But no, that would be too beautiful a dream. Were we going in cattle trucks like the last time? Or in the black transport? Then someone saw climbing the hill a white lorry with a huge Red X on it — then others — a long column of them coming in our direction. We could not believe our eyes. Then at last we realised that it was really true, this story of the Red X taking us over. Tears came into our eyes, and we could not speak for emotion.

American troops reached Mauthausen on 5 May 1945. They found nearly 10,000 bodies in huge communal grave. There were 110,000 people alive in the camp (28,000 of them Jews). The Americans very generously gave them their own supplies of chocolate and jam: unfortunately their starved bodies could not take such rich foods and a further 3,000 people died after liberation. Over 120,000 people had died at Mauthausen altogether, most from disease, or simply worked to their deaths.

The two Elsies had both survived, and they returned to Brussels, where they were reunited with Robert. Elsie senior provided the illustrations for a book of poems by her fellow prisoner Yvette Guilmin, published in 1946: they included a drawing of young Elsie that she had made in St Gilles prison and smuggled out.

I should before familiarising you with a prisoner's life, so different to anything you could imagine when free, tell you in detail about the odyssey which was ours between the torturing

BRUSSELS, MAY 10th, 1940, 5 a.m.

     The booming of guns in the distance awakened us both, Georges and I.
Another foreign aeroplane being driven off the territory was the thought that
passed thro' our minds and we turned over to sleep again. Sleep, however, was
impossible, for the booming became louder and more insistent. At last we were
fully awake and aware that something unusual was happening. The anti-aircraft
came into action and the crash of bombs added to the noise. We rushed to the
balcony and told the children (E. and B.) to dress. A fleet of aeroplanes was
flying just overhead, flashing silver in the morning sunshine. "It's war" said
G. "Ah les cochons"! Yes, it was war - a little more than twenty years after
the war that was to end wars. Since then all Europe has known war and the
Belgians, with their memories still fresh from 1914-18, not the least. So they
came out from their homes like the rats of the Pied Piper in families and dozens,
pouring into the routes that lead to France or to the coast, all fleeing from
the advancing invader.

     On Saturday, May 11th, British and French troops entered Brussels and
were passing all day long with tanks and cannons thro' the principal thoroughfares.
"Thumbs up" was the mutual greeting of the British Tommies and the Brussels
population. The same day G. received orders from his office to work in Ypres
and Poperinghe on the following Monday. On Sunday evening, news came through
that the Germans had broken thro' the Albert Canal - the situation was serious -
G. always far-sighted, knew that if he reached Poperinghe on the following
Monday, he would not be able to return to Brussels, so it was decided that the
children and I should accompany him and stay for a few days in Ypres by E.'s
godfather (who had invited us in case of war) until we could see more clearly how
the war was turning. Accordingly I packed up a few things, and Monday morning
early we took the train (the last, by the way, to leave Brussels). Arrived in
Ypres by our friends we spent the best part of the time listening in to the news.
The Germans continued to advance rapidly and on the following Friday, all the
people not of Ypres were invited to leave the town. Only one direction was

*Elsie Marechal's account of her wartime experiences.*

interrogations and the atonement which drove us to Germany,
first into the prisons then into the concentration camps.
I don't wish to do that. I prefer instead to familiarise you with
a few poems and songs which I used to make up as much to
occupy myself as to amuse the people with me, but above all
to keep up the incredible morale which allowed us to laugh at
our tyrants, even at the most critical times ... May we always
remember with pity all our dear departed, their suffering, their
courage, their smiles their friendship, their heroic death ....

Young Elsie married in the following year (1947), and set up her own
home, also in Brussels. Both Elsie and Robert worked in the Congo,
where Elsie senior visited them on at least one occasion in the fifties.
    Elsie kept in touch with old friends from the Training College
after the war, especially Winifred Jary, who lived in Great Yarmouth:
her activities are frequently mentioned in the College magazine in the
decades after the war. She, with Elsie junior and Robert, stayed with

POÈMES
ET CHANSONS
DES PRISONNIÈRES

D'YVETTE GUILMIN

Illustrations de POLLY MARECHAL,
toutes deux condamnées à mort

Imprimerie Jacques CODENNE, s. a.
19-21, Rue de Bruxelles
Namur
1946

*The cover of Yvonne Guilman's book,
with illustrations by
Elsie 'Polly' Marechal.*

Win in the summer of 1948. She came back to England in October 1950, visiting her mother and Win, who noted that 'she was looking much more her old self.' When she again visited Win in Gorleston in July 1952, Win noted in the magazine that 'Elsie has regained her sparkle and vivacity and looks her old self again.' In the summer of 1961, she and a friend toured England in a caravan, parking for a time in Yarmouth, where she met Win once more.

By the early 1960s, she was spending her winters in Nice. With both her children in Africa, she was living alone in a small flat in Brussels. However, by 1963 Elsie junior was back in Brussels working as a masseuse, and although Elsie senior wintered as usual in Nice she was back in Brussels for a family Christmas. At this time, too, she moved into a new flat in her adopted city. This was at 204 Rue Edith Cavell, the street in Brussels named after the Norfolk heroine of the previous war.

Elsie Marechal died on 25 March 1969: she is buried in Brussels.

# 10

# Elsie Tilney

## EARLY LIFE

**Elsie Maude Tilney** was born in Norwich on 3 October 1893. Her father, Albert Joseph Tilney was a bookseller's assistant and later a stationer's clerk. In 1889 he married Hannah Rachel Chapman, a dressmaker. They had five surviving children, Elsie being the third (two other children died very young). The two elder children were Edith, born in 1891, and Albert, born in 1892. Elsie came next, followed by Frederick in 1897/8 and Wilfred in 1900.

Census returns and other records show that the family moved fairly frequently, always in the west part of Norwich. In 1891, they were living at 3, King's road, Lakenham. At the time of the 1901 census they were at 95, Gloucester Road, and in 1903-6 they were living at 43, Hughendon Road. In 1911 they were at 64, Hall Road: Elsie was now aged sixteen and was at school.

The family were worshippers at the Surrey Street Chapel in Norwich. This had been formed by Robert Govett, formerly a curate at Saint Stephen's Anglican church. He was an eloquent preacher and, becoming convinced that baptism should be for adults rather than for children, he began holding his own services in a chapel in Surrey Street, Norwich, built largely at his own expense. Govett preached there until 1901, when he was succeeded as pastor by David Panton, who was himself to be pastor for forty years. It was Panton whom Elsie would have known when she came to worship at the Chapel. The chapel's centenary booklet summed up his work:

His 24 years of 'full-time' ministry were fruitful indeed, and greatly blessed of God. The undenominational traditions were maintained, also the doctrinal position of the church. That the Holy Spirit was at work was abundantly evident in the large attendances at the prayer meetings and Bible readings, as well as on the Lord's Day. Conversions were the usual thing and baptisms followed. The Sunday School also was a hive of Spiritual activity, and reached a peak of over 600 scholars and 60 teachers and officers. Conversions were numerous and many of today's teachers were scholars of this period. Added to the signs of a live 'Church' was a new and widening missionary interest. Mr Panton had a great influence over young folk in spiritual matters, and being intensely missionary-minded himself he often stressed the yielding to God of the whole personality. Many were the young men and women — and some older — who surrendered their lives to God for service overseas or in the homeland during this period of his ministry.

Elsie was one of these youngsters. She may well have regarded 15 February 1903 as the turning point of her life. At the age of nine, she was admitted to worship at the Surrey Street Chapel. Her sister Edith, two years older, was admitted on the same day, and her brother Albert followed three years later.

The Chapel's missionary work began with the Misses Hunter, who sailed to China in 1906 (when Elsie was thirteen). They were followed by several others during the years before the First World War. They were supported by a group of Chapel members called the Foreign Mission Band: the Tilneys were regular subscribers.

*Surrey Street Chapel, where Elsie Tilney worshipped.*

## THE CALL

Elsie's own first work was with the Mildmay Mission to the Jews in London: this had been founded by John Wilkinson in 1876. However, her main field of work was in North Africa. She went out in 1920 to the North African Mission, based first at Bone, later at Djerba Island. She was very much on her own. Two married couples did follow her to North Africa in 1921 and 1923, but both couples were very many miles from Elsie.

Elsie was not one of the most frequent letter-writers, but the few that exist from her give a vivid impression of her life in Algeria. She was based at Djerba Island, once mentioning slight illnesses and once a story of an accident with her primus. It smoked and spoiled the taste of her food, and on one occasion, when cleaning the smoke stains off her ceiling, the head of the brush fell off, giving her a bad cut just below the eye. She was able to buy a better stove.

However, she always brushed away personal details, preferring to talk about her work. In 1934, she writes thanking for a gift of £1, which was spent on that month's rent of the Gospel Hall, which she was hiring at 19/6 a month. She was fully occupied in visiting native and European ladies' homes. One convert was a former Roman Catholic, Madame Verdier, followed by her husband and her mother. She clearly travelled. In one letter she mentions a bus ride back to Djerba 'in the dark of ante-dawn'. Typically, she mentions this only because she found herself sitting next to a man in European clothes: he turned out to be a member of the Jewish community in Djerba, and the manager of a small bank. She had a copy of the Bible in French with her, and soon they were discussing religion. The man, a Mr Cohen, invited Elsie into his Djerba house to meet his wife.

Her work often involved charity work among the poor. She went to the local Hospital three times a week and spoke with the mothers there: 'Often little Arab or Jewish children are the means of opening doors to new homes'. A letter written to Mrs Spelman, a member of the Surrey Chapel, in February 1935 shows how her thoughts and actions were all for others:

Thank you so much for your loving gift of £1 from the 'Women's Own'. Some of you will never know what a help this means —

with the exchange low and the high price of living, and the constant calls for help from really poor natives. I was glad to be able to pay for the local doctor to visit two Arab homes. In one a girl of about 15 has been ill for a long time. She has no mother, and her father has frequently to be away in his fishing boat for days at a time. There are two younger children. I would have taken Sasseya the sick girl to nurse in my spare room but it would have meant having the sister and brother as well. However the

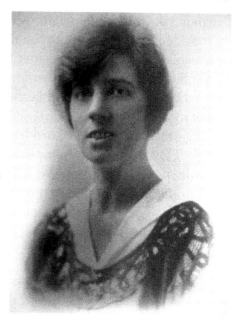

*Elsa Tilney, Norwich's 'righteous'.*

doctor came with me to meet Sasseya (at 8 am). The father and a young lad who works with him were sleeping on a hard bed built in the wall whilst Sasseya and her sister and brother were asleep on a mat on the floor. The doctor examined Sasseya and found her to be developing tuberculosis so he suggested her going daily to the Hospital for injections. Since he has arranged for her to stay in the hospital and the young sister too as she has a cough and the brother chicken pox. I am glad that the Lord has made it possible through your kind gift for something to be done for these poor children. I am sure that the girl Sasseya loves the Lord Jesus and the old deaf father listens with interest as the children take it in turn to shout my messages into his ear. The same morning I took the doctor into another home in which I am always made welcome, the first Arab house I ever visited in Djerba. There the mother who is shortly expecting another child was covered with sores and her mouth was so full of ulcers that she could neither eat nor drink. The doctor's wife gave me a box of straws for drinking lemonade which I quickly took round and a tin of milk and the poor mother found she

could take the warm milk for which she was so grateful. She repeated her thanks in the Name of the Lord Jesus I know that she loves him and her daughter too, whose name is Rebba. Rebba's husband had left her and I prayed that he might return. This he eventually did and I called to rejoice with her when her mother exclaimed before several other women visitors: 'Oh, Mademoiselle, the Lord Jesus has answered your prayers. Oh! I love Him!' This poor woman the doctor [treated] for 'Swinepox' and arranged for her to have medicine from the Hospital: she is already getting better. But Oh! The poverty! Do pray for the dear Jewish people here — and the Arabs, and the European people — and for me.

In 1935, Elsie moved to Gabes. Life was difficult at first, she could not find suitable premises and was forced to stay in a hotel which was noisy. The police warned her against going out of the town at night — and Roman Catholics had 'got away her children's class'. However, things improved in the following year: she moved from her first hotel to one owned by a Protestant Christian, which made her life easier; 'I have a small but very nice quiet room. The food is good and everyone is kind.'

In her letters, Elsie is always positive, writing home 'the welcome into Arab homes and in the Jewish village has been far beyond my expectations'. Of course, there must have been many difficulties and tribulations for this brave lady living on her own. At one point, the police actually forbade her to visit a 'fanatical' village, but she was eventually able to visit and had, she said, a good reception. In 1936, she records that a young Arab of good family has been accompanying her, and as a result she has been able to visit many houses in the Oasis: she was clearly working with the poorest members of the community as she describes their houses as being made of palm branches.

Elsie spent the summer of 1932 in London, working with Jews, but later summers were spent in Paris. In August 1934, for example, she asked the Surrey Chapel worshippers to pray for her work among Jewish girls there. She was nearly killed in Paris in 1935 when she stepped off the pavement and was almost knocked down by a car: a passer-by pulled her back just in time. Her 'rescuer' was a Jew, and she

asked the people of Surrey Chapel to remember him in their prayers. She was back in Paris in March 1936: she visited the Mosque there and gave away copies of the Gospel.

While she worked, the shadow of Nazi Germany was spreading over Europe, with its military threats and its anti-Jewish doctrines. In March 1938, they took control of Austria, annexed it to Germany and began to persecute the Jews living there. Many put their children onto trains and sent them to England for safety, the well-known 'Kindertransporte'. Typically, Elsie took direct action. While in Paris, she had met Leon Bucholz, a Jewish man who had been deported from Vienna earlier in the year, leaving behind his wife and one-year-old daughter, Ruth. Elsie was able to restore the little girl to her father: she travelled to Austria and rescued Ruth, bringing her back to Paris on 23 July.

Elsie was still making annual visits to her home city. She was in Norwich in 1938, and attended a birthday celebration for Reginald Warmoll of the Chapel. She was again in Norwich at the end of 1939, even after war had broken out. She decided not to return to North Africa but instead to go back to Paris and work with the Jewish child refugees who had fled there.

## IN OCCUPIED FRANCE

Elsie was in Paris when the city was occupied by the Germans in June 1940. The Foreign Mission Band voted to send her £10 but were unable to do this as they knew only that she had been living in a house run by an American missionary society. A year later, they were still uncertain whether she had received the money: they had passed the money to the British Foreign Office, but had heard no more. However, in 1942, they were able to forward £2 to her for emergency dental treatment. She was also being paid 300 francs a month by the American consul.

In fact, like all citizens of 'enemy' countries, she had been interned by the Germans, perhaps at first within the houses where they lived, later in camps; perhaps firstly at Besançon, but from September 1942 at Vittel. This is a spa town in Lorraine in North East France, still famed for its health-giving waters. It had one enormous hotel and several small ones, and these were turned into an internment camp, primarily

for people with American and British passports. Inmates did their own cooking and ate in their rooms.

Later in the war there were new arrivals. When the Warsaw ghetto was dissolved in 1943, several hundred Jews there were found to be in possession of passports from South American countries. These included a poet, Yitzak Katznelson, and a young Polish man called Sashe Krawek. These Jews were sent to camps while their fate was decided, some to Bergen-Belsen and about 300 to Vittel including Katznelson and Krawek. The South American countries declined to recognise the passports as valid, and the fate of these men and women was sealed: they were rounded up to be sent

 הצופן

ICI FURENT INTERNÉS (JANVIER 1943-AVRIL 1944)
300 JUIFS DE POLOGNE
QUI APRÈS DE CRUELLES PÉRÉGRINATIONS
PÉRIRENT A AUSCHWITZ LE 1ER MAI 1944
VICTIMES DE LA BARBARIE NAZIE.
PARMI EUX SE TROUVAIT
LE GRAND POÈTE ITSHAK KATSNELSON
= PLAQUE APPOSÉE PAR LA
FÉDÉRATION DES SOCIÉTÉS JUIVES DE FRANCE
6 FÉVRIER 1955 =

Plaque at the Vittel internment camp.

to concentration camps: some committed suicide rather than be sent away. At least 169 Jews, including Katznelson, and also a three-month-old baby who had been born in the camp, left Vittel on 18 April 1944, bound for Auschwitz. Katznelson was gassed on 30 April. He left behind a long poem to record the fate of his race. A small part runs:

I had a dream,
A dream so terrible;
My people were no more,
No more!

I wake up with a cry:
What I had dreamed was true:
It had happened indeed,
It had happened to me.

We will never know if Elsie and Yitzak ever met each other in Vittel: perhaps he was in her English class.

The remaining Jews in Vittel were rounded up on 15 May to be transported to the gas chambers, but one escaped capture: Krawek. Elsie had been teaching him English in the camp, together with the other Poles there. He managed to evade the round-up on 15 May because Elsie hid him in her bathroom! She kept him hidden over the following days, which became weeks and then months. Clearly, she ran a very great risk by hiding him: she would have been severely punished, perhaps executed, had the deception been discovered. On 10 September 1944, the camp was liberated by the American Army: the ordeal was over, and Krawek had survived, after spending sixteen weeks hidden by Elsie.

Two other women in Vittel have been recognised for their work with the Jews in the camp, Sophia Skipwith and Madeline Steinberg. They prepared a list of the Jews in Vittel with South American passports and smuggled it to the French Resistance with a note telling them that these inmates were in great and immediate danger. In her memoirs, Sophia writes that 'one man (a Jew) survived in the bathroom of Miss Tilney, an old, devoutly Protestant spinster, who was so annoying that he was almost driven to give himself up'. She did not add, as she might have, that Miss Tilney may have been an annoying old spinster, but she was someone ready to risk her own life to save that of a stranger.

Elsie seems to have been acting as 'camp archivist' and apparently destroyed 'inconvenient' documents that might reveal origins of inmates. After the camp was liberated, she stayed on, working for the Americans, and was able to help with the repatriation of about two hundred Jews to Palestine. She did this work until April 1945, and then worked as secretary in an American Rest Hostel for a further month. She was able to show testimonial letters from her American employers when she later applied to live in the United States.

## AFTERWARDS

After the war, Elsie apparently continued her work. In 1952, a report to Surrey Chapel says that she was believed to be back in missionary service with the Paris Evangelical Mission. However, another report of the same years lists her among the 'retired workers'. Elsie travelled to Lisbon at one stage, and later worked with the Swiss Mission in South

Africa until about 1960, when she returned to the United Kingdom. In about 1963, she emigrated to Dade County Florida, where she lived close to her younger brother, Frederick: she worked as a nanny. In 1974, she broke her hip in a fall; while in Hospital she had a stroke and died on 1 October 1974. Frederick died three years later, in 1977.

Surrey Street Chapel is still flourishing. It relocated to Botolph Street in Norwich in 1985, but retained its historic name and is now known as the Surrey Chapel.

Leon and Ruth Buchholz had to go into hiding when the Germans took Paris. The family was incredibly lucky: both Leon and Ruth survived the war, as did Ruth's mother in Austria; after the war, the family was reunited. When Ruth grew up, she married Alan Sands and lived in England. It was their son, Philippe, who uncovered Elsie's story while researching his family's history.

In 2013, Elsie Tilney became only the twenty-first British citizen honoured as 'Righteous among the Nations' by Yad Vashem, the Holocaust Martyrs and Heroes Remembrance Authority.

# 11

# Eugenia Zagajewska

Earlham Road cemetery in Norwich, contains many thousands of graves, including a small number of graves of Polish people killed in the Second World War while they were based at airfields in Norfolk. One of these graves is of a woman, Eugenia Zagajewska, who died aged just twenty-one. This grave has always intrigued me, and over the years I have been able to put together Eugenia's story, which is now told here for the first time.

Eugenia Zagajewska was born on 7 September 1924, the daughter of Wladyslaw Zagajewski and his wife Anna Zagajewska. They had a second daughter, Anna, three years later (born 16 August 1927). The family lived in the village of Ostrow, in the Sokal area, on the River Bug, within the Lwow district. The area is in what is now the Ukraine (the city is now Lviv rather than Lwow), but in Eugenia's lifetime was in the extreme north-east corner of Poland. They lived there at the time of the birth of their children and were still there at the outbreak of the Second World War, when Eugenia was fourteen years old.

This is a part of Europe which has undergone many changes, and been a part of several different countries at different dates. It was made up mainly of three groups — the majority, like Eugenia and her family, were Polish-speaking Roman Catholics. There was a large minority of Ukrainian-speaking Orthodox Christians, and also a large Jewish population.

The region was part of the Austrian Empire until the end of the First World War. The Ukrainians then declared themselves an independent country, and declared the Lwow region (the area often known as

*Sokal, Poland, Eugenia's childhood home.*

Eastern Galicia) to be part of that country. By 1919, the Polish had taken the area by force. They then had to fight the Russians, who invaded Poland in 1920. The Polish Army, under General Piludski, defeated the Russians at a battle known as 'the miracle of the Vistula'. East Galicia formally became part of the Independent Polish Republic in 1923. Eugenia was born in the following year.

Eugenia and Anna thus grew up in an independent Poland, but it was not to last. On 1 September 1939, the German army invaded Poland. The British and French Governments had made an alliance with Poland and declared war with Germany two days later. The Polish people naturally hoped that her two allies would attack Germany from the west and divert some of its army from the attack on Poland. However, they did nothing, and the German advance continued. So, on Eugenia's fifteenth birthday, her country was being invaded from the west by a mighty German army.

Ten days later, things got very much worse: on 17 September, the Russian Army invaded Poland from the east. It turned out that the Russians had made a secret pact with Germany to divide the country between them. Lwow was hurriedly put into a state of defence, ready to fight both the Russians and the Germans, but the Germans withdrew

from the area which, it had already been agreed, was to be occupied by Russia. Lwow fell to the Red Army on 22 September.

By the end of the month, the whole of Poland was being occupied by the Russians and the Germans. Those who could, mainly young men but including some women, fled to continue the fight elsewhere, but most people, like Eugenia and her family, had to stay and await their fate.

## THOSE WHO FLED POLAND

Getting out of Poland was not easy, as the country's enemies lay to both east and west. A part of the Polish Navy did manage to escape to Britain, making the perilous journey around north Germany and Denmark into the North Sea. Based mainly in Scotland, it went on to play its part in the North Sea and the Atlantic, and was present at the D-Day landings.

Other members of the Polish armed forces just fled as best they could, the most common escape route being south through the Adriatic and then through Italy (which was still neutral), or by ship through the Mediterranean. About 80% of the Polish Air Force escaped to Romania, and thousands of them then made the long trip west to continue the struggle. Some of these Poles came straight to England, but most sought refuge in France: when Hitler invaded France they took part in that country's defence. When France was defeated, those who could escaped once more, this time to Britain: about 7,000 members of the Polish Air Force reached this country. There was nowhere else in Europe to go, and they gave Britain a nickname it should be proud of; 'Last Hope Island'.

Polish airmen made an important contribution to the success of the Battle of Britain in 1940. At first they fought as elements within the British Royal Air Force, but soon had both fighter and bomber squadrons of their own, and several of these were based in Norfolk.

The Poles, like other countries, saw that women could play an important role in the armed forces, not actually fighting, but in doing essential administrative roles, and thus freeing up men for the front line. There were a small number of Polish women – just thirty-six - who wanted to join the Polish Air Force, either among the incomers or already resident in Britain; these thirty-six women were trained

with British women in the Women's Royal Air Force and took up their stations in the airbases where Polish airmen were based, including Norfolk bases like Coltishall.

## THOSE WHO REMAINED IN POLAND

Stalin's Soviet Union was ruthless in the way it exploited whole peoples, moving them hundreds or thousands of miles from their homelands and using them as slave labour: both the conditions in which they travelled and the conditions under which they worked were appalling and many thousands died. The first thing the Russians did, having conquered the eastern half of Poland, was to help themselves to everything of value. Eugenia herself wrote about this:

> When the Soviets entered Polish borders and established their rule, they would have guards on the Polish-Soviet border, which would vigilantly keep watching that no one passes from one side to the other. Under their rule Poland had changed as they started to move everything to Russia. They would take wares from the shops, fabrics, many other products, wheat, agricultural equipment, food for animals, cattle, home furniture's; after two months they had plundered Poland to the ground, they would loot even radios. [Yet] They would organise meetings during which they would exalt their lives in Russia.

Stalin's purpose was not to conquer Poland, but to dismember it. It was divided among the nearest Soviet states, the Lwow area becoming part of Ukraine. Rigged elections purported to show that the population were in favour of the union.

After this came deportations, at first voluntary, with people being enticed with hopes of a new life, hopes that turned out to be completely false. Later, there was no pretence at voluntary movements, many thousands being transported with no choice in the matter. Eugenia wrote:

> Later on they started deporting Poles to Russia. First went the settlers, who were told they were going to be "sent freely" and were forced to sign documents that proved they wanted to do

that of their own accord. 60 kilometres to a German colony as it later turned out we were going further afield, towards Russia. We drove to Russia quite long time, almost a whole month. On the way we could see only mountains, some clay houses. One day the [railway] car stopped and we arrived at a small town Soswa [Swerdlowsk]. They told us we will be redistributed among kolkhoz work camps.

Eugenia's description comes from an essay she wrote as a schoolgirl. It is clearly an extremely restrained description: the journey by train was made in indescribably awful conditions, and many Poles died on the way, or soon after reaching their destination. She does not give a date for her journey, but forty-nine trains left the Lwow region on 2 May 1940, of which six went to Swerdlowsk. One left from the railway station at Eugenia's home town of Sokal. It had 1,241 Poles crammed on board, Eugenia and her family probably among them.

Those Poles who were fit enough, including fifteen-year-old Eugenia, were put to work. As she recalled in her essay:

They took us to [some place] and put in barracks, gave three days of rest and on the fourth day they sent us to work. The work was in the pine forest to harvest resin. The pay was manageable, so as one could have something to eat and clothe. In that particular place people were good to Poles. As for the cleanliness it was very tidy in their houses as well as in barracks where the Poles resided.

Health service was very poor. One was exhausted after all day of hard labour. People were often getting sick and worn out all the time. I had always been ailing. When you went to the doctor he would measure your temperature and unless the fever was over 40 degrees Celsius you had to go back to work and would not be relieved from duty. Because of that many people died.

It wasn't allowed to talk about God and you had to obey their rules. Polish woman were not treated any different than man. They had to work as hard as them. If someone couldn't come in and didn't turn up at work they put people in prison. Children were taken to orphanages where they were taught Russian and songs about Stalin. They always said to children that there is no God and it was forbidden to mention God and anything related. They lied and were getting youth used to

communism. Poles were not allowed to talk about politics or about other countries. When Soviets found out they would put people in prison for couple of years.

Eugenia spent her sixteenth birthday in Russia. It must have seemed that her whole life would be spent there, but in June 1941, everything changed: Germany invaded Russia. Russia and Poland were now on the same side, enemies of Nazi Germany: a pact between the two countries was signed in London on 30 July 1941. Young men and women could serve in the fight against Germany, and children could be trained up for the war, but Stalin did not want them fighting on the eastern front. Instead they were released in batches from August 1941 onwards, and had to make their own way south to the Caspian Sea and find a way across it into the safety of Palestine. Many thousands of women and children went with their men on this long trek. The new army took care of them, and included them in their evacuation plans, sharing the crowded ships by which the Poles left from Krasnovosk to cross the Caspian Sea to Pahlavi in Persia. Men, women and children continued to arrive through 1942: many had to make their own way from their labour camps, and many thousands died on the journey. However, large numbers did survive what became known as the 'Trail of Hope', or, equally realistically, the 'Trail of Bones': about 41,000 Polish combatants and 74,000 Polish civilians eventually made it.

Whatever the exact figures, this is a tiny proportion — less than 10% - of all the Poles whom Stalin had deported. It does not appear that Eugenia's parents or sister made it to freedom, but their exact fate is not known.

Eugenia was one of the lucky ones: we do not know the dates or any details of her journey, but by her eighteenth birthday (7 September 1942) she was in Palestine. She was placed at a volunteer training school for girls (Szkola Mlodszych Ochotnkzek). It was here that she wrote the school essay describing her experiences which has already been quoted.

The purpose of the training was for the girls to take part in the war effort, serving with one of the Polish armed forces based in England. In October 1943, there were over 1,000 women in camps in Palestine and North Africa, so Eugenia was there for her nineteenth birthday (September 1943). The women came over to England in late 1943

onwards, the last group, six hundred Polish women, arriving in July 1944: Eugenia was among them. The thirty-six Polish women who had trained with the WAAF now came into their own, helping train these newcomers from Palestine: the course was extended from five weeks to two months because of the new recruits' poor English. The basic training was at Falkirk (Bantaskin House), Scotland, followed by training with the WAAF at Wilmslow, Cheshire. Women in the Polish Air Force were known as WAAFKI. A few worked as mechanics, just one as an intelligence officer, others in domestic, mechanical, clerical and technical posts, but most of them, like Eugenia, were employed in clerical work. Almost 1,500 women served in the WAAFKI in Britain. The women were never fully integrated into the Polish Air Force, but were allowed to wear PAF cap badges and insignia to distinguish them from their British counterparts.

After her training at Wilmsow in July and August, Eugenia served with the Polish Air Force at its Headquarters in London: not far from the Albert Hall it is now a museum. She was employed in a secretarial position. She had finished her training and taken up her post by her twentieth birthday in September 1944.

By that time the war situation had changed. The Russian army was advancing on Germany from the east and Allied forces were established in northern France, beginning the long march towards Berlin. The Poles in Britain must have thought that, after so many years, their cause was in the ascendant, and that the long-hoped for freedom was in sight. However, it must already have been clear that once Russian troops were in Poland it was going to be difficult to dislodge them.

In fact it was not possible. At the Yalta Conference in February 1945, almost the whole of Eastern Europe was conceded to be Stalin's sphere of influence. Many of the Poles fighting for freedom in Britain knew they would not be able to return. In the House of Commons, in February 1945 Churchill offered the 'citizenship of the British Empire' to those Poles who felt unable to go back, but many people, both Polish and English, felt that Poland had been betrayed. The Member of Parliament for Norwich, Henry Strauss, who may have known some of the Coltishall Poles, was so outraged that he resigned from the Government. The British Government still recognised the Polish Government in exile in Britain as the official rulers of Poland, but on 6

July 1945 it withdrew this recognition, in favour of the Soviet-inspired Communist regime in Warsaw. The war was over but the Poles in Last-Hope Island had nowhere to go.

Eugenia celebrated her twenty-first birthday in London on 7 September 1945. By this time she had a boyfriend. One of her friends, Ada Slusarek, was based at Coltishall, and Eugenia had met a cousin of hers, Wladislaw Slizewski six months Eugenia's junior: they fell in love. He was in the Polish navy, based in Scotland. We do not know how many times they all met in Coltishall, or indeed in London, but there was a concentration of Polish airmen – and women – at Coltishall after the war. From 8 August 1945, Coltishall became Station RAF Coltishall (Polish), with personnel from several fighter squadrons and a Polish commander. There were quite a number of Polish women there too, in various roles, secretarial, cooking, medical and dentistry to name just a few, so it formed a base for social life amongst this group of mainly young exiles.

Certainly, all three were in Norfolk on a holiday break at Easter 1946: Eugenia stayed on the base with her cousin Ada, Wladislaw had digs nearby. There was plenty to celebrate: Wladislaw and Eugenia were now formally engaged, and he had been released from active service to study at the Polish Naval College at Bridge of Allan in Scotland. As good Roman Catholics, they no doubt went to church services on Good Friday and Easter Sunday, either on the base or at St John's Catholic Church in Norwich, where many of the Polish community worshipped.

Easter Monday was a holiday, and a fine day. The three went down to the river Bure at Lammas, a popular leisure spot. The Poles even had a 'canoe' there, really an aeroplane auxiliary fuel tank, with a metal strip welded to its underside as a primitive keel, to keep it steady in the water and prevent it overturning. He had already used this several times before on his own, now it was time to show off to his girlfriend.

The three lay on the grass by the river, the canoe beside them: perhaps Eugenia was reminded of her childhood days, playing in and around the river Bug. At about 3.15, they dragged the canoe into the water. Wladislaw got in, and Eugenia followed, sitting in front of him: Wladislaw had the paddle and Ada watched from the bank as they gingerly set off into the deep water. After just a few minutes, Wladislaw was seen to lean forward, either to speak to Eugenia or to adjust

his position. This was enough to cause the unstable craft to overturn, plunging the couple into the water. The river was over six feet deep, with muddy banks and bottom, and with reeds growing up. As they splashed about, Eugenia panicked, grabbing Wladislaw tightly by the arm, leaving him with just one arm free to swim with. Ada desperately called out to her cousin to swim to the shore. He shouted back (presumably in Polish): 'I can't: she hold me', and they both went beneath the water. In a few moments, Wladislaw surfaced alone.

*The grave of Wladislaw Slizewski.*

They were several other people on the spot, both Polish and English, and they came to the rescue as best they could. John Reeve, who was 86, was looking at the scene from his garden beside the river: he found a rope and flung it but Wladislaw was

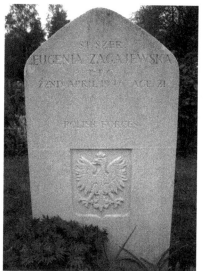

unable to grab it. A Polish airman and his wife leapt off the bank, only to find themselves stuck in the mud. Eventually they were able to bring Wladislaw ashore. Another local man, Walter Foster, applied artificial respiration but it was too late: Wladislaw was dead.

Meanwhile somebody had ran to the nearest telephone box and summoned help from the police and from Coltishall. The local policeman arrived at 3.35, to find artificial respiration being applied. He took possession of Wladislaw's watch: it had stopped at exactly 3.20. He was then told that there was a woman still in the water, presumably caught in

*The grave in Earlham Road cemetery of Eugenia Zagajewska, died 22 April 1946.*

the reeds as she was not visible: he was able to organise the retrieval of Eugenia's body. By this time an Air Force ambulance had arrived from Coltishall, and the two bodies were placed inside and taken back to the base. An Inquest was held there a few days later.

The final act took place five days later. At 10.40 am on Saturday 27 April, the two were buried side by side in part of the Earlham Road cemetery in Norwich reserved for burial of members of the Polish Air Force. The entire Polish community turned out and the Polish national anthem was sung. In October, the Commonwealth War Graves commission placed their standard gravestones on the graves. Eugenia and Wladislaw, young Poles had died in Norfolk while in the service of their country, two thousand miles from their home.

'In death they were not divided.'

On the left, the tribute to the Poles in Norfolk, St John's Roman Catholic Cathedral and above, the memorial to the Polish community on the site of the cemetery of St Andrew's Hospital, Norwich.

# Index

Lightning Source UK Ltd.
Milton Keynes UK
UKOW05f0043010317
295599UK00001B/71/P